WORLD WAR II
MILWAUKEE

WORLD WAR II
MILWAUKEE

······· ★ ·······

MEG JONES

Published by The History Press
Charleston, SC
www.historypress.net

Copyright © 2015 by Meg Jones
All rights reserved

First published 2015

Manufactured in the United States

ISBN 978.1.46711.762.3

Library of Congress Control Number: 2015914238

Notice: The information in this book is true and complete to the best of our knowledge. It is offered without guarantee on the part of the author or The History Press. The author and The History Press disclaim all liability in connection with the use of this book.

All rights reserved. No part of this book may be reproduced or transmitted in any form whatsoever without prior written permission from the publisher except in the case of brief quotations embodied in critical articles and reviews.

For Mom.
Remember when I brought Scholastic Books order forms home from elementary school and you said I could buy as many books as I wanted even though money was tight and we couldn't really afford them?
Your literary investment paid off, Mom.

CONTENTS

Preface	9
Introduction	13
1. Captains on the Bridge	17
2. Hard Hat Divers	25
3. Milwaukee's Singing Mayor Joins the Fight	37
4. The Harley on the Submarine	49
5. The World's Machine Shop Retools for War	61
6. Milwaukee's Nazis	73
7. The Nazi Resister	79
8. The Associated Press's Man in Berlin	95
9. The Dean of Broadcast News	107
10. The Woman on the Front Lines	117
11. The Prophet and the Warrior	129
Bibliography	143
Index	147
About the Author	155

PREFACE

I didn't notice the e-mail until a couple days after it popped into my inbox at the *Milwaukee Journal Sentinel*. Greg Dumais, acquisitions editor at The History Press, wrote to see if I would be interested in writing a book about Milwaukee's World War II history. I e-mailed back that I was preoccupied at the time because I was leaving for Afghanistan in a couple days to write about a different war.

The irony was not lost on me.

Since the September 11, 2001 attacks—the current generation's Pearl Harbor—I had traveled to Iraq four times as an embedded reporter with Wisconsin troops, plus another three trips to Afghanistan. I was leaving in less than a week for a fourth, and what I hoped and expected to be my last, visit as an embedded reporter in Afghanistan. I wanted to write about how wars end, when the sign is flipped from Open to Closed. Journalists usually focus on the tip of the spear—the troops leading battles—but I wondered what happened when the spear was no longer needed and was packed up and sent home.

A Wisconsin National Guard engineering unit was part of the massive packing up and closing down of combat operations in America's longest war. Billions of dollars' worth of equipment was being sent back to the United States, given to the Afghans or destroyed, and I planned to write about the Wisconsin packers taking part in the monumental task. Forward-operating bases and military facilities I had seen built up over the years were being torn down or turned over to local authorities. Each time I

Preface

went to Iraq and Afghanistan between 2003 and 2014, I noticed more permanent facilities being built, tents replaced with permanent buildings, an indication that the short war predicted in 2003 and 2004 probably would last for years. Just as the massive bases in Iraq dissolved in 2011, when American troops left, the airfields and outposts in Afghanistan were reverting back to the Afghan landscape, leaving behind ghostly footprints in the sand where tents, motor pools and aircraft hangars had once stood.

I e-mailed Dumais that I would be gone for a while, but if he was still interested in a book about Milwaukee during World War II, he could get back in touch with me later. Which he did. I was appreciative of Dumais' interest in me, and I'm grateful to be given the chance to write this book. I've written many stories about history, the military and veterans for the *Milwaukee Journal Sentinel*, and as I began to think about the approach of this book, I quickly latched on to Franklin Van Valkenburgh, captain of the USS *Arizona*, about whom I wrote on the sixty-fifth anniversary of Pearl Harbor, and Douglas MacArthur—two men with strong ties to Milwaukee who stood on the decks of ships three and a half years apart in vastly different circumstances.

I thought of using the stories of Van Valkenburgh and MacArthur as bookends along with chapters on Milwaukee businesses that contributed to the war effort, Milwaukee journalists who chronicled the rise and fall of Hitler and the Nazi Party, the little known pro-Nazi Volksbund in Milwaukee and the incredible story of Mildred Fish Harnack. Before I started research, I knew about most of the people who eventually ended up in the book, though I admit I had never heard of Associated Press Berlin bureau chief Louis Lochner until I was reading through H.V. Kaltenborn's papers at the Wisconsin Historical Society and a librarian mentioned that the society also had Lochner's papers. It seemed like each day I learned something new about the city where I had spent much of my childhood, a city where I consider myself incredibly lucky to work as a journalist.

Early into the project, I decided this book would not be a long, comprehensive history of Milwaukee during World War II but would instead connect a few of the most interesting, surprising and unusual dots of the conflict and Milwaukee. It would illustrate some of Milwaukee's warriors, witnesses and workers who helped win World War II.

I gained a newfound respect for the war correspondents who covered World War II and Vietnam. It's not easy covering wars, wrestling with logistics and austere conditions, but most correspondents do it because they want to tell the stories of the men and women fighting far from home. I

Preface

wondered what H.V. Kaltenborn, Louis Lochner and Dickey Chapelle would say if they could see the satellite modems, laptop computers, digital cameras, voice recorders and cellphones modern journalists use. I'm sure they would have embraced Twitter, Instagram, blogging and podcasting and seen social media as simply another way to tell their stories. I have never had any problems as a female journalist in a war zone, partly because many women are serving in the U.S. military and partly because trailblazers like Dickey Chapelle paved the way for us.

Many people helped me with this project but none more so than my good friend Elaine Schmidt, a performing arts critic for the *Milwaukee Journal Sentinel* and an accomplished author who has written many books. Elaine was incredibly helpful in negotiating the nuts and bolts of writing a book, as well as lending much-needed moral support.

My thanks and appreciation to Bill Jackson, archivist at the Harley-Davidson Museum; Gayle Ecklund and Jennifer Pahl at the Milwaukee Public Library; Ric Koellner at DESCO Corp.; and staff members at the Wisconsin Historical Society in Madison, the German Resistance Memorial Center in Germany and the Wisconsin Maritime Museum in Manitowoc. Carl Zeidler's niece Anita Zeidler was gracious to meet me for coffee at Colectivo on Milwaukee's east side and answer questions about her uncle. Mike Latta, once I finally tracked him down by contacting the race car driving school where his son is an instructor, was very generous with his time, chatting by phone from Monterey, California, where he lives on a sailboat. I know it was difficult for Mike to talk about the loss of his father, Frank Latta, on board the USS *Lagarto*, and I'm grateful he agreed to speak to me.

One of the great benefits of my job at the *Milwaukee Journal Sentinel* is getting the chance to interview World War II veterans and their families and telling their stories. The window is rapidly closing. Soon, all that will be left is their recorded memories.

INTRODUCTION

As the first Nakajima "Kate" torpedo bombers swarmed over the USS *Arizona* unleashing their lethal cargo, Franklin Van Valkenburgh sprinted to the one place a ship's captain needed to be: the bridge. It was a bright Sunday morning in Pearl Harbor, a place many folks in Van Valkenburgh's hometown of Milwaukee had never heard of before December 7, 1941.

Van Valkenburgh had eleven minutes to live.

The *Arizona*'s air raid alarm sounded at 7:55 a.m., and the first wave of rising sun–emblazoned planes dropped their armor-piercing bombs a few minutes later.

Tied up to the *Arizona* on Battleship Row was the repair ship USS *Vestal*, whose captain also grew up in Milwaukee. Cassin "Ted" Young ran onto the deck of his ship and began firing an antiaircraft gun at the enemy planes that peppered the sky.

The last of four bombs to score direct hits on the *Arizona* penetrated the deck near ammunition magazines in the ship's forward compartments at 8:06 a.m. Seven seconds after the bomb struck, the ship exploded—yellow flames shooting out from the sides, a huge cloud of black smoke rocketing upward like a volcanic eruption.

Young was blown into the water by the force of the explosion. Van Valkenburgh's body was never found; only his U.S. Naval Academy class ring and two brass buttons from his dress white uniform were discovered when fires that raged for two days were finally extinguished.

Introduction

Many people died that day, and many became heroes. Van Valkenburgh was awarded the Medal of Honor. Young also received the nation's highest honor for valor. He was killed less than a year later in the naval battle of Guadalcanal.

Years before the Japanese attack on Pearl Harbor, another Milwaukeean had predicted such an attack. William "Billy" Mitchell had warned the American military that someday planes would sink ships, that Hawaii was vulnerable to such an attack and that Japan was rapidly building a military that one day could rival the largest in the world. And if such a war did start between America and Japan, Mitchell predicted it would begin with a sneak attack on Pearl Harbor in good weather on a Sunday morning, when America was literally and figuratively asleep, and Japanese bombers launched from aircraft carriers would lead the assault. Mitchell did not gloat when all that he predicted came true. By the time Pearl Harbor was attacked, the man considered the father of the U.S. Air Force had been dead for six years.

As the first reports of the attack on Pearl Harbor began filtering out to the rest of the world, H.V. Kaltenborn was in the CBS radio office in New York. The Milwaukee-born Kaltenborn, who portrayed himself in the 1939 Frank Capra film *Mr. Smith Goes to Washington*, saw the first flash announcement a few minutes before his regular Sunday afternoon broadcast. Many Americans learned of the attack from Kaltenborn.

It was evening in Germany when the news came. Associated Press Berlin bureau chief Louis P. Lochner, who grew up in Milwaukee and got his start in journalism in his hometown, heard it in a phone call. He knew his days as a free man in Germany were numbered. Four days, to be exact.

When Franklin Roosevelt spoke to a stunned nation the next day, Milwaukee, in many respects, was already on a war footing. Its factories had retooled assembly lines to start producing war materiel to be shipped overseas through the Lend-Lease Act. The city that billed itself as the "Machine Shop of the World" was perfectly positioned to switch gears to war production. While thousands of the city's young men enlisted in the military, its factories churned out ammunition, ships, military motorcycles, artillery tractors, radio components, hard hats and suits for navy divers, steam turbines and gears that turned propellers on hundreds of ships, B-26 bomber struts and bomb fuses. Because of the city's rich manufacturing history, factories did not need to be built; they were already here and quickly switched to war production. And the atomic bombs that ended the war in Japan? Much of the equipment required to develop and construct the bombs dropped on Japan was built in Milwaukee.

Introduction

Among the thousands of Milwaukeeans who enlisted in the military right after Pearl Harbor was the city's mayor. Carl Zeidler had been elected the year before with the help of Robert Bloch, a twenty-two-year-old short story and advertising copy writer who wrote campaign speeches and pamphlets and devised now-standard election gimmicks such as balloon drops and positioning a giant American flag behind the candidate. Years later, Bloch would write the book on which Alfred Hitchcock's film *Psycho* was based, as well as episodes for the original *Star Trek* TV series.

Zeidler quickly made a name for himself as the singing mayor, belting out tunes at rallies and meetings. After joining the Naval Reserve within months of the attack, Zeidler was assigned to a Merchant Marine ship that left the Panama Canal Zone for Pakistan in September 1942, its cargo hold filled with plane parts and ammunition, heading into waters filled with roving packs of German U-boats. It never arrived. Zeidler's death hit the community hard and may have dramatically changed Wisconsin politics. The handsome and charismatic Zeidler had aspirations for higher office and might one day have become governor or a congressman, perhaps even unseating Wisconsin's incumbent senator in 1946. Instead, a different World War II veteran, a little-known circuit court judge named Joe McCarthy, won that race.

War with Germany for the second time in as many generations posed challenges for a city like Milwaukee, which embraced its Teutonic heritage. German was still widely spoken in homes and shops. When America entered World War II, more than 40 percent of Wisconsinites were either German immigrants or first-generation descendants. Even more problematic was the small but vocal group of pro-Nazi sympathizers in the city. In 1937, the German-American Volksbund in Milwaukee opened Camp Hindenburg in nearby Grafton, where children learned military drills and wore Nazi uniforms and families attended picnics. Pro-Nazi bund rallies in Milwaukee often ended in violence as protesters stormed the stage at the Auditorium to tear down Nazi flags.

By the time Hitler became chancellor of Germany, Mildred Fish Harnack, who grew up in Milwaukee, was already living in the country, working as a teacher and translator. She met German exchange student Arvid Harnack at the University of Wisconsin–Madison in the early 1920s, fell in love and immigrated to her husband's homeland. Mildred Harnack fought the Nazis in her own way: with words. She and a small group of Communists formed a resistance group that the Gestapo later dubbed the Red Orchestra, sending information to the Soviet Union about German military plans and recruiting

Introduction

other Germans to join in efforts to undermine the Nazi regime. Eventually, they were arrested, tortured and convicted. Most were executed—even Mildred Harnack, who was initially sentenced to prison. But her prison sentence was overturned by Adolf Hitler, who personally intervened in her case and ordered her execution by guillotine. Mildred Harnack was the only American civilian woman murdered on direct orders from Hitler.

When World War II finally ended, another military commander with strong ties to Milwaukee stood on the deck of a ship but under far different circumstances than Van Valkenburgh and Young. General Douglas MacArthur stood on the crowded deck of the USS *Missouri* as the flag that flew over the U.S. Capitol on December 7, 1941, flapped in a breeze. MacArthur watched the Japanese surrender before he affixed his own signature—using Wisconsin-made Parker Duofold fountain pens—to the documents that ended World War II. MacArthur's father commanded the Twenty-fourth Wisconsin Regiment during the Civil War—they were the first father-and-son Medal of Honor recipients—and Douglas MacArthur was living in the city when a Milwaukee congressman nominated him to West Point. MacArthur barely escaped Japanese forces invading the Philippines, promising to return. He did and was supreme commander of Pacific forces on September 2, 1945, when the war that ripped apart the world ended.

This book is not a comprehensive history of Milwaukee during World War II. Instead, it highlights interesting businesses and people in Milwaukee that helped defeat fascism and the fascinating coincidences that became part of the Second World War's narrative in Wisconsin's largest city.

1
CAPTAINS ON THE BRIDGE

It would be Franklin Van Valkenburgh's fate to die in the opening salvo of World War II for America. The U.S. Naval Academy graduate and career navy commander had trained for more than three decades for war and had never fired a shot in anger or seen action until the last few minutes of his life.

Van Valkenburgh ran a tight ship. In the U.S. Navy, that meant he was a commander who ensured his men were well trained and ready. His sailors knew the rules and followed them. Inspections aboard the USS *Arizona* were rigorous, and if anything was amiss, it meant sailors didn't get shore leave.

An apprentice seaman named Oree Cunningham Weller remembered Van Valkenburgh as tough but fair. Knowing an inspection was scheduled the next morning, Weller painstakingly cleaned the navigator's office, repainting battle ports, polishing brass and even standing on a desk to wipe an overhead steam line. As Van Valkenburgh strode smartly across the boat deck, Weller saluted and reported the office ready for inspection.

Weller, who died in 1993, told an oral historian:

> *Looking around briefly, he jumped up on the desk and ran his white glove the length of the steam pipe. It came away clean, and I was barely able to hide the smirk of supreme satisfaction. He examined the file drawer cavities and complimented the paint job. One more success like that and I would be in need of a new jumper to contain my swelling chest. Pausing for a moment, and*

World War II Milwaukee

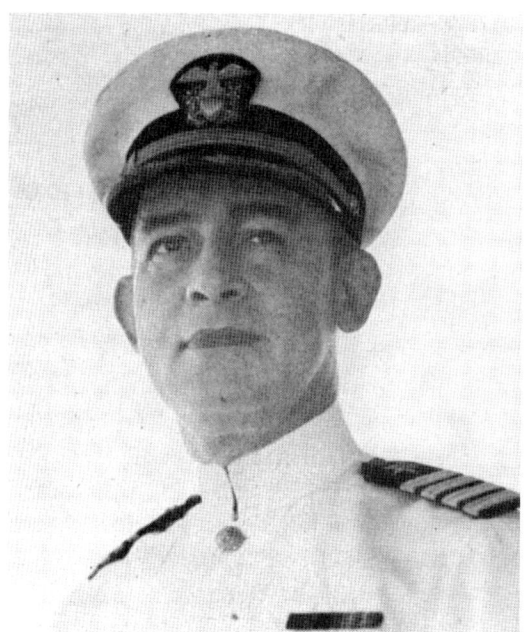

Franklin Van Valkenburgh made the navy his career after graduating from the U.S. Naval Academy in 1909. He was named captain of the USS *Arizona* in February 1941 and was standing on the bridge directing the defense of his ship when the *Arizona* blew up. Rescue crews found only his Annapolis class ring and two buttons of his uniform. He was posthumously awarded the Medal of Honor. *Courtesy of the U.S. Navy.*

appearing to be ready to depart, the Captain noted the switch for the small oscillating fan mounted on the bulkhead above the door. He reached over and switched the fan off. When the blades spun to a stop, he saw a thick fringe of greasy dust on the leading edge of each dirty and corrosion-covered brass blade. The yeoman quickly noted the discrepancy, and I forgot about liberty.

Van Valkenburgh had assumed command of the *Arizona* ten months before its last day. It was a relatively old ship; in 1914, assistant secretary of the navy Franklin Roosevelt had watched the keel-laying ceremony of the vessel that would become the enduring symbol of the surprise attack on America. It was christened by the seventeen-year-old daughter of an Arizona pioneer with a bottle of champagne and a bottle of the first water to pass over the spillway of the Roosevelt Dam in Arizona. The water was a compromise following much debate in Arizona, a dry state where alcohol sales were banned.

The ship missed out on World War I, escorted President Woodrow Wilson to the 1919 Paris Peace Conference, was featured in a Jimmy Cagney movie in the 1930s and was used for training exercises. Though America was not yet at war, it was evident to most that the country might soon be—which is why, in 1940, the *Arizona* and the rest of the Pacific fleet moved from bases

in California to Pearl Harbor to train for what many considered to be the inevitable: an Asian foe.

The *Arizona*'s captain knew it. In a November 4, 1941 letter to his aunt, he wrote about the extensive training and preparations:

> *We never go to sea without being completely ready to move on to Singapore if need be, without further preparation. Most of our work we are not allowed to talk about off of the ship. I have spent 16 to 20 hours a day on the bridge for a week at a time, then a week of rest, then at it again.*
>
> *Our eyes are constantly trained westward, and we keep the guns ready for instant use against aircraft or submarines whenever we are at sea. We have no intention of being caught napping.*

Born in Minneapolis, Van Valkenburgh moved to Milwaukee when he was a toddler. His father was a prominent lawyer, also named Franklin Van Valkenburgh, who served as Milwaukee assistant city attorney and U.S. attorney for Wisconsin. His lineage included ancestors who emigrated from Holland and fought in the Revolutionary War with George Washington, in the War of 1812 and on both sides of the Civil War. His great-grandmother's brother was Daniel Wells Jr., who represented the Wisconsin First Congressional District in the 1850s.

Van Valkenburgh grew up on Milwaukee's east side, attending Cass Elementary School and graduating from East Side High School, later renamed Riverside High School. Appointed to the U.S. Naval Academy in Annapolis in 1905, he spent the rest of his life in the military. He served on numerous vessels ranging from battleships and submarine tenders to gunboats and destroyers, did postgraduate work in steam engineering at the Naval Academy and worked a succession of engineering officer posts. He returned to his alma mater as an instructor.

Van Valkenburgh slowly worked his way up through the navy's chain of command, spending three years in the Office of Chief of Naval Operations and then as inspector of navy materiel at the New York Navy Yard. He was promoted to captain in 1937 while commanding a destroyer tender and then spent three years in New York as inspector of materiel for the Third Naval District. In February 1941, Van Valkenburgh became captain of the *Arizona*, flagship of Battleship Division 1 stationed in Pearl Harbor. As the flagship for the division, the *Arizona* was also home to Rear Admiral Isaac C. Kidd.

For months, Van Valkenburgh trained his sailors, putting them through battle scenarios and tactical exercises in the waters near Hawaii. Its last

training cruise included a night firing exercise on December 4 with battleships *Nevada* and *Oklahoma*. The ships returned to Pearl Harbor the next day, Friday. The *Arizona* anchored at Berth F-7 on Battleship Row; behind it in F-8 was the *Nevada*. Nearby in F-5 was the *Oklahoma*.

On Saturday, Van Valkenburgh ordered the usual inspections of his ship. His men worked and got ready for shore leave—1,511 sailors and marines going about their lives unaware that Japanese forces were massing hundreds of miles away preparing to kill as many of them as possible. Kidd told the crew after morning inspection that the ship was headed to California soon for an overhaul.

Moored right next to the *Arizona* was the repair ship *Vestal*, whose captain, Cassin "Ted" Young, was a fellow Milwaukeean.

Young was born in Washington, D.C., but at the age of two moved to Milwaukee, where his father ran a drugstore in the city. He was appointed to the U.S. Naval Academy in 1912 and served on a battleship after graduation before switching to submarines for several years. Like Van Valkenburgh, Young was steadily promoted through a variety of assignments and taught at the Naval Academy. By the 1930s, he was serving on a battleship and a destroyer and then was promoted to the rank of commander before taking over a submarine division.

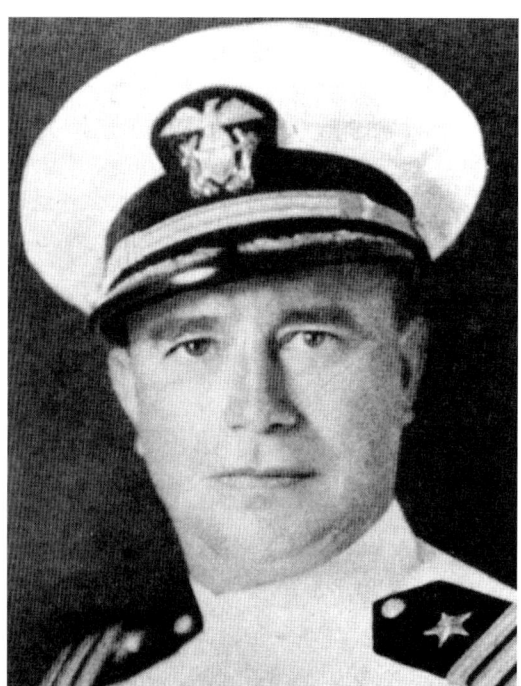

Cassin "Ted" Young was captain of the USS *Vestal*, which was tied up alongside the USS *Arizona* when the Japanese attacked Pearl Harbor. He earned a Medal of Honor for heroism on December 7, 1941, swimming through burning oil after being blown off his ship when the *Arizona* exploded and then managing to steer the *Vestal* to safety. *Courtesy of the U.S. Navy.*

Captains on the Bridge

Twenty-four hours before the attack, Young boarded the *Arizona* for a conference with commanders. Then the *Vestal* was secured for the day, and half the ship's crew was given liberty. On Saturday evening, both Young and Van Valkenburgh stayed on board their ships, eating dinner in their cabins.

The next morning, men were working, sleeping in their bunks, eating breakfast, bathing and shaving, getting ready to go ashore, writing letters and reading newspapers. They were not preparing for battle. Japanese military commanders knew that, which is why they struck Hawaii on a Sunday morning, just as Billy Mitchell had prophesized years before.

In Milwaukee, many were listening to the radio broadcast of the Chicago Bears and Chicago Cardinals football game at Comiskey Park to see which team would face the Green Bay Packers in the league championship. The Bears won 34–24 and then trounced the Packers, 33–14, a week later.

Most of the *Arizona*'s band was on deck preparing to play the national anthem at 8:00 a.m. for the daily flag-raising ceremony. Then the first bombers dropped out of the sky. The air raid siren sounded at 7:55 a.m. on the *Arizona*, followed soon after by the signal for general quarters. Van Valkenburgh and Kidd were seen running toward the bridge.

As Van Valkenburgh emerged from the conning tower to the bridge, he was hit by a burst of shrapnel, which tore into his abdomen.

"He fell to the deck. Refusing to be carried to safety, he continued to direct the action," secretary of the navy Frank Knox told reporters three months later. "When the bridge was a blazing inferno, two officers attempted to remove him, but he ordered them to abandon him and save themselves."

Aviation machinist mate first class Donald Graham vividly described the explosion that broke the *Arizona* in half. In a statement on December 13, 1941, in the USS *Arizona* Action Report, Graham, who earned a Medal of Honor and a Navy Cross for his actions, heard the noise of the bomb exploding, followed by an awful "swish" and hot air blowing out of the compartments.

"The signal gang, quartermasters and all hands on the bridge went up as the signal men were trying to put out a fire in the signal rack and grabbing signal flags to hoist a signal, the whole bridge went up, flames enveloping and obscuring them from view as the flames shot upward twice as high as the tops," said Graham.

Most eyewitnesses reported seeing the *Arizona*'s entire bow leap out of the water from the force of the explosion.

Jim Foster, an antiaircraft gunner, was off duty when he saw men coming down a hatch at 7:55 a.m. He heard the loudspeaker but couldn't make out

what was being said. Realizing it was an emergency but not yet knowing the Japanese were attacking, Foster tried to go up to his battle station but faced a crush of men coming down the deck ladder he was trying to ascend. The antiaircraft gun at his battle station was on the starboard side of the boat deck. Foster was the first of what were supposed to be sixteen men to arrive. But only two others joined him.

Right after Foster got to the antiaircraft gun, Van Valkenburgh and Kidd ran past the mainmast on their way to the ship's command center on the bridge. They were in full uniform. The admiral saw Foster was alone and stopped to tell him to man his battle station, holding his arm briefly. Foster and two others stood helplessly by their gun because shells, like most ammunition for weapons aboard the *Arizona*, were locked up below. Eventually, men at a few of the battle stations managed to fire .50-caliber antiaircraft guns at Japanese attackers.

But within a few minutes, the fatal bomb hit the *Arizona*. As the ship's forward magazine blew sky high, Foster's nose was broken and his legs and feet were burned. He turned toward the bridge, where Van Valkenburgh and Kidd had sprinted, and saw it was on fire.

"It was like pouring molten metal in there. It must have been the powder coming up out of the stack on the bridge. They died in that fire," Foster told the authors of *The USS Arizona: The Ship, the Men, the Pearl Harbor Attack, and the Symbol that Aroused America*.

The ship sank right side up within nine minutes as 1,177 of the *Arizona*'s crew died, more than half of all Pearl Harbor attack casualties.

Meanwhile, Young ran from his cabin to the *Vestal*'s deck when he heard the attack, organizing his sailors and firing one of the ship's three-inch antiaircraft guns at Japanese planes swirling overhead. Two bombs hit the *Vestal*, one on each side. The port side bomb penetrated three decks and exploded in a hold; the starboard side bomb opened a five-foot hole in the bottom of the *Vestal*.

When the *Arizona* exploded at 8:06 a.m. right next to the *Vestal*, more than one hundred sailors were hurled into the oil-slick burning water as body parts and debris from the *Arizona* rained down on the repair ship. Among those tossed into the ocean was Young. Water flowed into the engine room, and the *Vestal*'s second in command gave the order to abandon ship. As sailors jumped overboard, Young clambered aboard. Covered in oil, Young had swam through the burning water back to his ship.

Survivors heard him yell, "Where the hell do you men think you are going?" Young ordered his sailors to return to the *Vestal*, and as he calmly

walked across the deck, which was still being strafed, he shouted to his men to go to their battle stations and prepare to get the ship underway. They did. Despite working with only a fraction of the normal steam pressure from damaged pipes, the *Vestal* moved out into open water. Because the ship was on fire and listing, Young ran the ship aground. It was repaired and returned to action in August 1942.

Among the men killed aboard the *Arizona* were twenty-three sets of brothers, the only father-son pair on board and all twenty-one members of the ship's band. Band members were trained as ammunition loaders, and all instantly ran to their battle stations, where they died within minutes, becoming the only U.S. Navy band to form, train, fight and die together.

Van Valkenburgh's body was never found. Neither was Kidd's. When the *Arizona* blew up, Kidd became the first U.S. Navy flag officer killed in action in World War II and the first killed in combat against any foreign enemy. Navy salvage divers later found Kidd's 1906 Naval Academy class ring fused to a bulkhead on the ship's bridge. Only Van Valkenburgh's 1909 academy ring and two buttons from his uniform were recovered. At ceremonies honoring the fiftieth anniversary of the attack in 1991, Van Valkenburgh's son described receiving his father's class ring, which he wore.

"I lost the finest shipmate any man could have had on that day of infamy, and it left a void in the life of a twenty-two-year-old kid," said Van Valkenburgh's son and namesake.

Both Van Valkenburgh and Kidd are officially listed as missing in action; their names are etched on the wall of the white memorial that straddles the sunken ship. Both were posthumously awarded the Medal of Honor. Their final resting place is accorded an unusual honor: men and women on every U.S. Navy, Coast Guard and Merchant Marine ship sailing in to Pearl Harbor stand at attention at their ships' guard rails and solemnly salute as they pass by the *Arizona* in a tradition called "manning the rails."

Young received the Medal of Honor four months later from Admiral Chester W. Nimitz on board the *Vestal*. Within months, Young was promoted to captain and became skipper of the USS *San Francisco*, a heavy cruiser that was in Pearl Harbor on December 7 but not damaged. The *San Francisco*, under Young's command, took part in the Battle of Cape Esperance in the Solomon Islands in October 1942 and the naval battle of Guadalcanal the next month.

In the early hours of November 13, 1942, the *San Francisco* was part of a task force traveling near Guadalcanal, capital of the Solomon Islands, when a Japanese naval force was spotted. The *San Francisco* opened fire on

an enemy cruiser and minutes later trained its guns on another Japanese ship. In the darkness, the *San Francisco* accidentally targeted the American light cruiser *Atlanta*, killing an admiral and most of the crew on the bridge before realizing the fatal mistake. Green dye used to distinguish the *San Francisco*'s shells was later found on the *Atlanta*'s superstructure before it sank.

Minutes later, as the *San Francisco* fired at another Japanese ship, an enemy battleship and destroyer began firing on Young's ship. The *San Francisco* continued to fire its guns even after two batteries were put out of commission from shelling until the Japanese scored a direct hit on the navigation bridge. All officers on the bridge were killed or badly wounded except for the communications officer, who earned a Medal of Honor. Among the seventy-seven killed aboard the *San Francisco* was Young. He was buried at sea.

Later that morning, as the *San Francisco* limped to a port for repairs, it was joined by light cruisers *Helena* and *Juneau*. Medical personnel from the *Juneau* transferred to the *San Francisco* to help treat scores of wounded men. An hour after the medics boarded the *San Francisco*, the *Juneau* was torpedoed by a Japanese submarine. The entire ship exploded in a column of flames and brown and white smoke that shot one thousand feet into the air, witnesses reported. The *San Francisco* and *Helena* were ordered not to stop to rescue survivors. By the time *Juneau* survivors were found floating in the sea, most had died from exposure and shark attacks. Only ten survived. All five Sullivan brothers were killed in the sinking of the *Juneau*, and news of the tragedy forced the War Department to create the sole survivor policy.

Following the deaths of Van Valkenburgh and Young, the navy named destroyers after the Medal of Honor recipients with their widows as ship sponsors. The USS *Cassin Young* took part in numerous battles in the Pacific. It was the last American ship to come under kamikaze attack when a Japanese pilot flew his plane into the *Cassin Young*, killing twenty-two sailors and wounding forty-five on July 29, 1945, less than a week before an atomic bomb was dropped on Hiroshima.

The USS *Van Valkenburgh* participated in the Battles of Iwo Jima and Okinawa and sailed into Nagasaki Harbor, where its men saw the devastation from the second atomic bomb. When the *Van Valkenburgh* was commissioned in August 1944, a sailor hoisted the flag that was flying on the *Arizona*'s fantail on the morning of the Japanese attack.

2
HARD HAT DIVERS

Stricken ships were still burning and smoldering when the first navy divers began salvage operations in Pearl Harbor. Long before scuba tanks made diving relatively easy, men lumbered under water clad in heavy canvas suits, huge weight belts and steel boots, seeing a submerged world through tiny windows from a cumbersome brass helmet.

Edward C. Raymer was a senior petty officer and leader of a navy diving crew. In his memoir *Descent into Darkness*, Raymer wrote vividly of his first dive inside the *Arizona*'s hull, a mission to find the missile that had made a hole below the mud line on the port side at the rear of the ship. A submarine torpedo man provided assistance as Raymer was sent to attach a lock on the propeller of the Japanese torpedo to prevent it from arming itself and exploding.

Before Raymer plunged into the water surrounding the sunken tomb, he familiarized himself with the layout of the *Arizona*. Then he pulled on the rubberized diving suit and stepped into thirty-six-pound lead-soled shoes. Assistants bolted the metal breastplate to his suit. He stood and thrust his arms through the shoulder straps of an eighty-four-pound lead-weighted belt. Finally, the heavy copper helmet was placed over his head, onto his shoulders and secured to the breastplate. In all, his suit weighed just under two hundred pounds.

Most navy divers like Raymer who built, repaired and salvaged vessels during World War II wore the Mark V helmet, and the majority of those helmets were manufactured in a small warehouse in Milwaukee. Diving

World War II Milwaukee

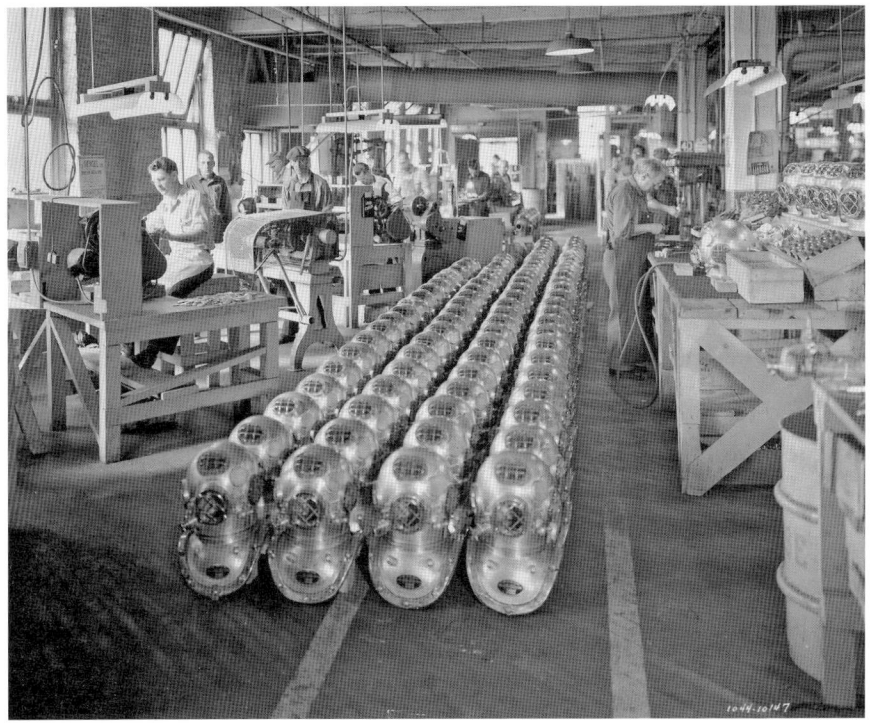

Mark V dive helmets are lined up at the DESCO factory in Milwaukee, one of the largest manufacturers of equipment used by U.S. Navy salvage divers throughout World War II. Navy contracts were usually for 100 to 250 helmets, which were shipped when the entire order was finished. *Courtesy of DESCO Corp.*

Equipment & Salvage Company, now known as DESCO Corp., had opened shop a few years before America entered the war, spurred by a quest to dive on the wreck of a famous World War I ship.

Raymer climbed down a ladder into the oil-soaked water and was submerged in total darkness. He was attached to the diving barge moored alongside the *Arizona* through his air hose and lifeline, which included telephone wires encased in rubber. Topside, someone spoke into a telephone receiver to help orient Raymer among the twisted wreckage. As he moved, a tender pulled in or let out the lifeline and air hose to prevent entanglements, but on a wreck like the *Arizona*, where only the mast and part of the ship's superstructure remained above water, that was tricky.

He slowly walked across the sunken deck of the *Arizona*, where men like Van Valkenburgh had run in the minutes after the Japanese attack started. Raymer forced open a hatch and sank into the blackness. He dropped down

to the third deck and moved into a compartment, feeling with ungloved hands toward the starboard bulkhead, the agreed-on starting spot for his mission to find the torpedo. All he could see was a light that glowed dimly, flickered and disappeared. Phosphorescence? he wondered. In *Descent into Darkness*, Raymer wrote:

> *Suddenly, I felt that something was wrong. I tried to suppress the strange feeling that I was not alone. I reached out to feel my way and touched what seemed to be a large inflated bag floating on the overhead. As I pushed it away, my bare hand plunged through what felt like a mass of rotted sponge. I realized with horror that the "bag" was a body without a head.*
>
> *Gritting my teeth, I shoved the corpse as hard as I could. As it drifted away, its fleshless fingers raked across my rubberized suit, almost as if the dead sailor were reaching out to me in a silent cry for help.*
>
> *I fought to choke down the bile that rose in my throat. That bloated torso had once contained viscera, muscle and firm tissue. It had been a man. I could hear the quickening thump of my pulse.*

He tamped down his queasiness, telling himself to breathe slowly and deeply as he felt his way to the door of the *Arizona*'s machine shop, listening to the sound of air hissing into the heavy copper helmet from his air hose trailing behind. Filled with lathes, drill presses and other equipment, the workshop had been a damage control station for one hundred *Arizona* crew members. Raymer figured the explosions had thrown the sailors like rag dolls, breaking their necks or decapitating them.

He found the hole in the side of the ship, though he couldn't find a torpedo. But he did find a detonator, and after feeling around the cone, he discovered a large-caliber shell with metal fins welded to the base. The Japanese had welded fins onto the shell so it would spiral down when dropped from a plane. On a later salvage dive, an unexploded bomb, which had fallen through several decks of the *Arizona*, was found by a different Mark V helmet–clad navy salvage diver whose leg got caught in a hole made by the bomb. It was found in a walk-in freezer underneath hanging sides of beef. The fifteen-inch, one-ton shell was manufactured in the United States for use by American coastal guns. It had been sold to Japan years before as scrap iron—the U.S. stamp was still visible at the base of the shell—and returned to drop onto America's flagship on a quiet Sunday morning in Pearl Harbor.

The Milwaukee men who started DESCO—which has never stopped making Mark V helmets since World War II—were a quirky pair. Max Gene

Nohl and Jack Browne were inventors, adventurers and sunken treasure explorers known as tin can divers because that's what they wore at first: diving helmets made from paint cans.

Nohl studied mechanical engineering at MIT and at the age of twenty-three designed a diving sphere based on a bathysphere he saw on display in Chicago, contracting with the Falk Corp in Milwaukee to fabricate it. He and Browne explored a sunken steamship together in Lake Michigan near Fox Point. Then Nohl moved to Martha's Vineyard to salvage a steamship used as a Prohibition rumrunner, drawing the attention of local media. A Hollywood producer named John D. Craig read the stories about Nohl's salvage of the rumrunner, contacted the Milwaukee diver and ended up helping out on the project—which turned out to be a bust. The ship's safe was empty, and the contraband scotch on board had been ruined by saltwater.

Craig was interested in salvaging the doomed Cunard ship *Lusitania*, sunk off the coast of Ireland in 1915 by a German U-boat with the loss of 1,198 passengers and crew members. Today, the *Lusitania* is accessible to divers breathing mixed gas, but in the mid-1930s, no diver could safely descend three hundred feet to the torpedoed ship. So Nohl began experimenting with new diving equipment designs and returned to Milwaukee to work with Browne. The pair devised a dive suit of canvas, which they took to the N.L. Kuehn Rubber Co. to make watertight. Norman Kuehn, the rubber company owner, ended up becoming a mentor and investor in DESCO, which opened for business in the Kuehn factory on North Fourth Street in 1937 with Browne as president.

Nohl worked with Dr. Edgar End, a Marquette University Medical School graduate and professor who studied the effects of decompression sickness on tunnel workers in Milwaukee. Nohl asked him for help in developing decompression tables for breathing a mixture of helium and oxygen to dive down to the *Lusitania*. End suggested using a decompression chamber at the Milwaukee County Hospital for testing the effects on humans working in deep water. Nohl used himself as a test subject, and in December 1937, he dove to a depth of 420 feet in Lake Michigan, breaking a record set by a U.S. Navy diver in 1915.

Their mission to salvage the *Lusitania* ended before they could splash into the Irish Sea. As war with Germany loomed, the British government restricted diving on the *Lusitania*, and the partners ultimately gave up their quest. Nohl parted with Browne and left DESCO for a variety of adventures—working with Johnny Weissmuller on Tarzan films, designing

a diving bell for tourists in Florida, harvesting sponges, underwater salvage and film work. He capitalized on his celebrity by appearing in whiskey and Blatz beer ads and on the TV show *What's My Line?*

Shortly after Pearl Harbor was bombed, Browne drove to Washington in his Ford loaded with diving gear to seek contracts with the U.S. Navy for DESCO's diving equipment. The navy agreed to pay $5,000 for three self-contained dive suits in January 1942. That initial small contract soon turned into a big demand for DESCO products, and within months, Mark V helmets, dive suits, weight belts, knives, boots, umbilical and communication cords and gloves were being made. Compact oxygen rebreathers were designed and built for special operations missions requiring divers to operate covertly without giving away their locations from air bubbles rising to the surface. Life vests for flight crews bailing out of planes into water were designed and manufactured. The company quickly expanded its workforce from 3 employees to 150, including many women hired to work on the soldering line. The first year, the company

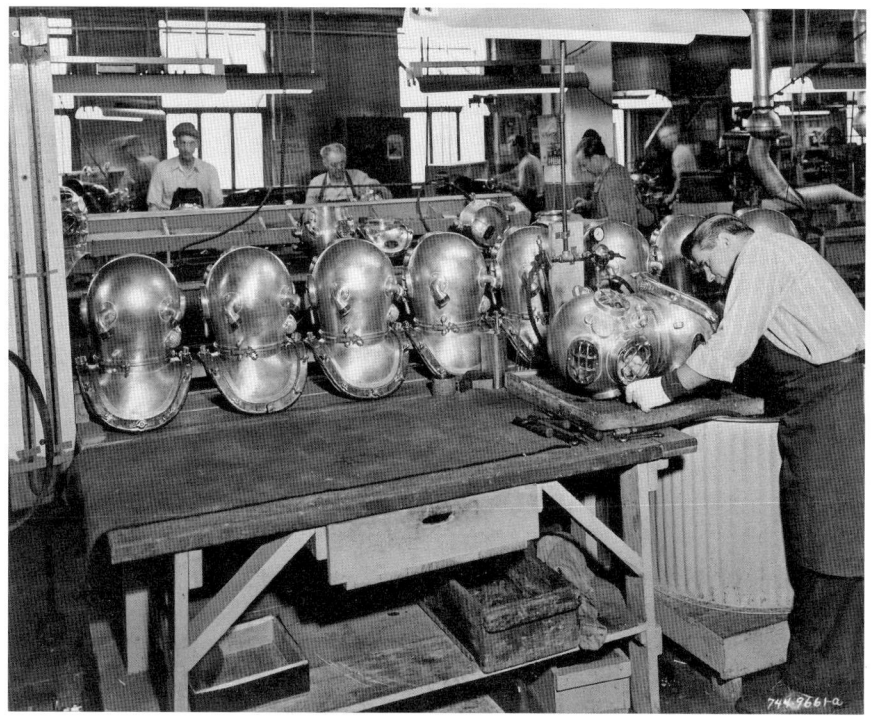

Employees at DESCO Corp. assembling communications and transceiver equipment on Mark V helmets used by U.S. Navy salvage divers. *Courtesy of DESCO Corp.*

World War II Milwaukee

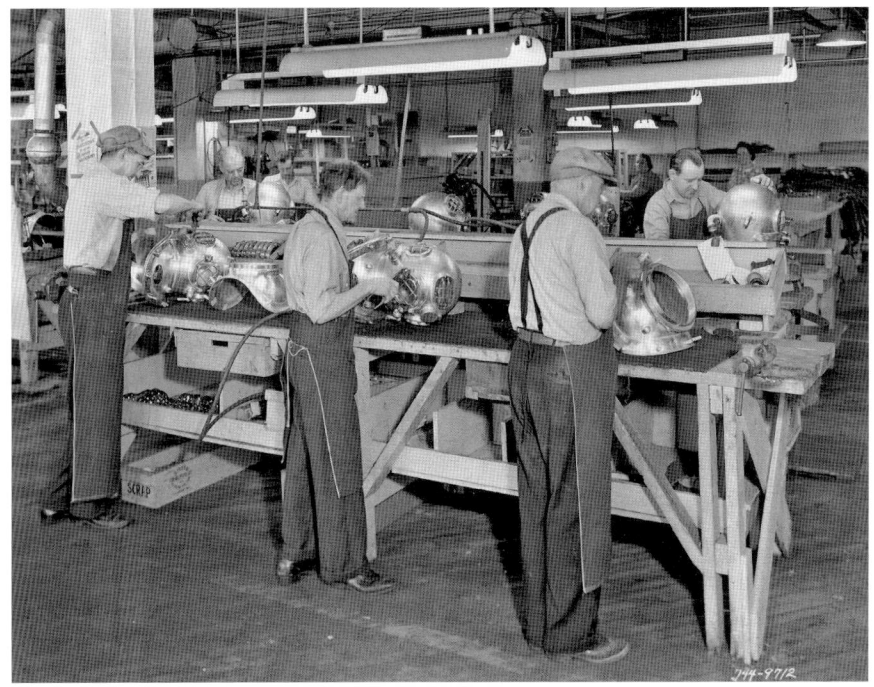

DESCO Corp. employees work on Mark V hard hat helmets destined for use by U.S. Navy salvage divers. *Courtesy of DESCO Corp.*

Opposite, top: A DESCO worker uses a hickory axe handle to bend thirty-two-inch squares of copper around wood patterns on lathes to make Mark V dive helmets. It took forty-five days to make each helmet. *Courtesy of DESCO Corp.*

Opposite, bottom: DESCO employees perform finishing work on Mark V helmets. The Milwaukee company has continuously manufactured the helmets worn by U.S. Navy salvage divers since 1942. Many of the Mark V helmets made during World War II are still in use or highly desired as collectibles. *Courtesy of DESCO Corp.*

shipped $80,000 worth of dive gear. By the next year, 1943, it had sold $450,000 of equipment, and in 1944, sales almost tripled to $1,250,000.

While other companies had been manufacturing the Mark V for years, the navy issued new drawings to change some aspects of the helmet to include wider breastplates and straps and interchangeable parts with older helmets. DESCO employees started from scratch, making patterns from the navy drawings and constructing molds. It took forty-five days to make each helmet, starting with thirty-two-inch squares of copper placed next to wood patterns on lathes as workers used hickory axe handles to bend the metal into the shape of a helmet. After many more

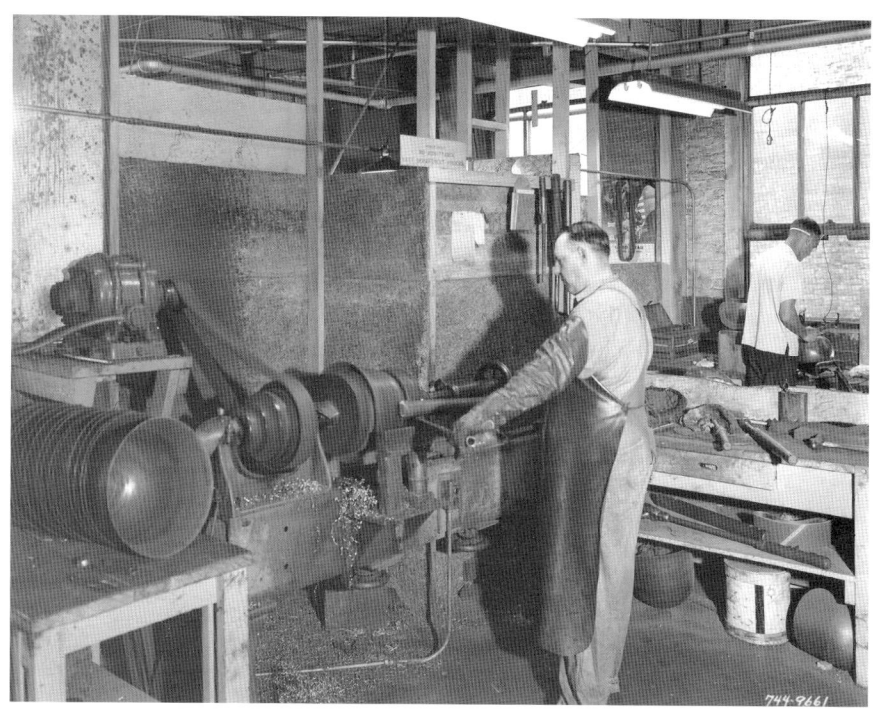

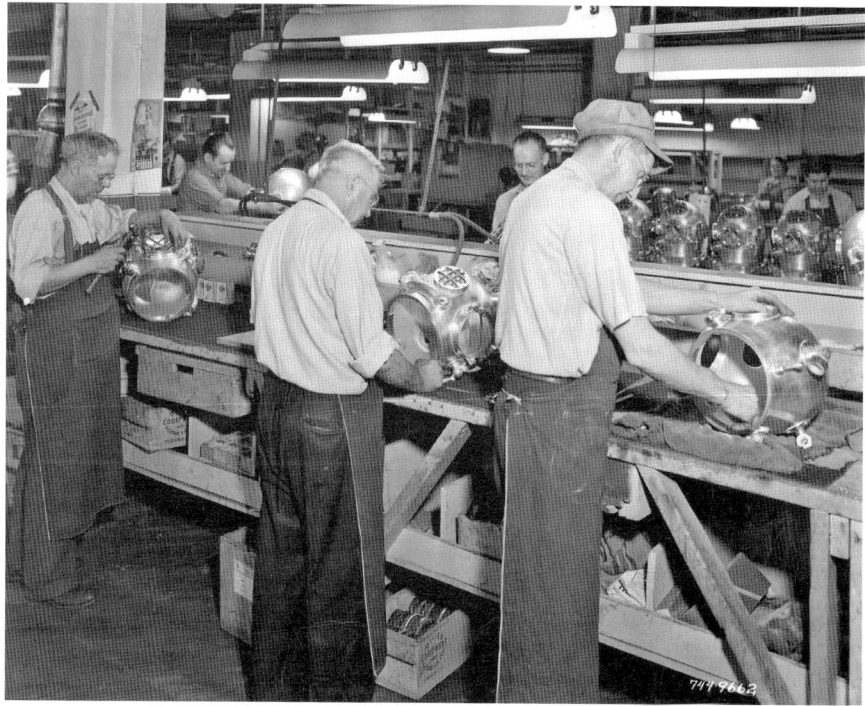

steps, workers wearing white gloves performed finishing work to prevent oil in their hands from leaving black fingerprints on the helmets.

A navy inspector based in the factory checked each piece of equipment, stamping the finished products with a unique mark featuring "USN" and an anchor. The inspector's stamp was kept in a safe when not in use.

"You'd get a contract from the navy for 120 to 150 helmets, and we never knew where they were going. Some were sent to Russia with the Lend-Lease program," said Ric Koellner, who started as head floor sweeper in 1980 and now owns DESCO.

"They were all used for salvage work. You can assume every ship salvaged from Pearl Harbor was done by divers wearing the Mark V. It was about the only piece of equipment you could use—it was constructed better than foreign helmets," Koellner said.

As DESCO turned out row upon row of gleaming Mark V helmets—3,500 during World War II, many of which are still in use—the company continued researching and innovating and, in 1945, built a pressurized tank to simulate diving at depth. Browne used the tank to dive to 550 feet, breathing a mix

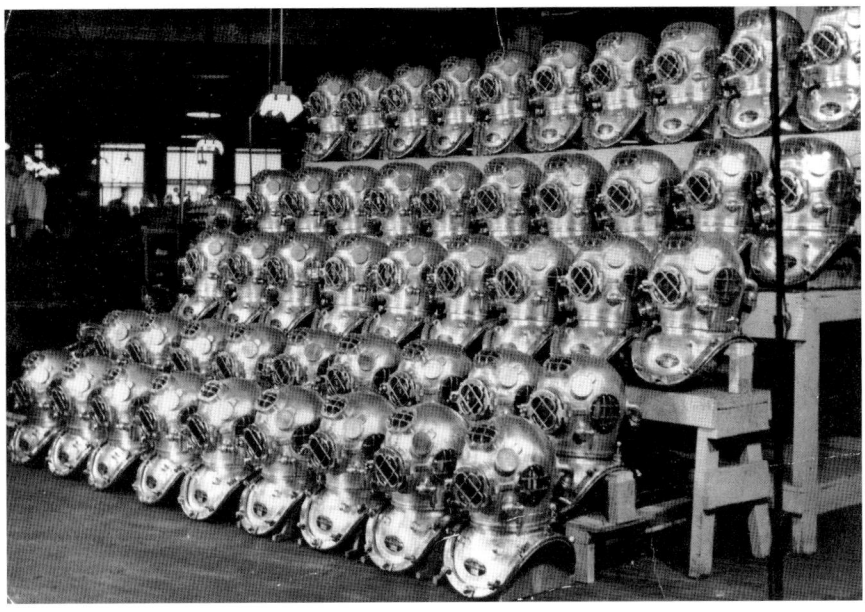

Mark V helmets manufactured at DESCO Corp. in Milwaukee wait for shipment to U.S. Navy salvage divers during World War II. A navy inspector was stationed at the factory during the war to check every piece of equipment, stamping the finished products with a unique mark featuring "USN" and an anchor. The inspector's stamp was kept in a safe when not in use. *Courtesy of DESCO Corp.*

Hard Hat Divers

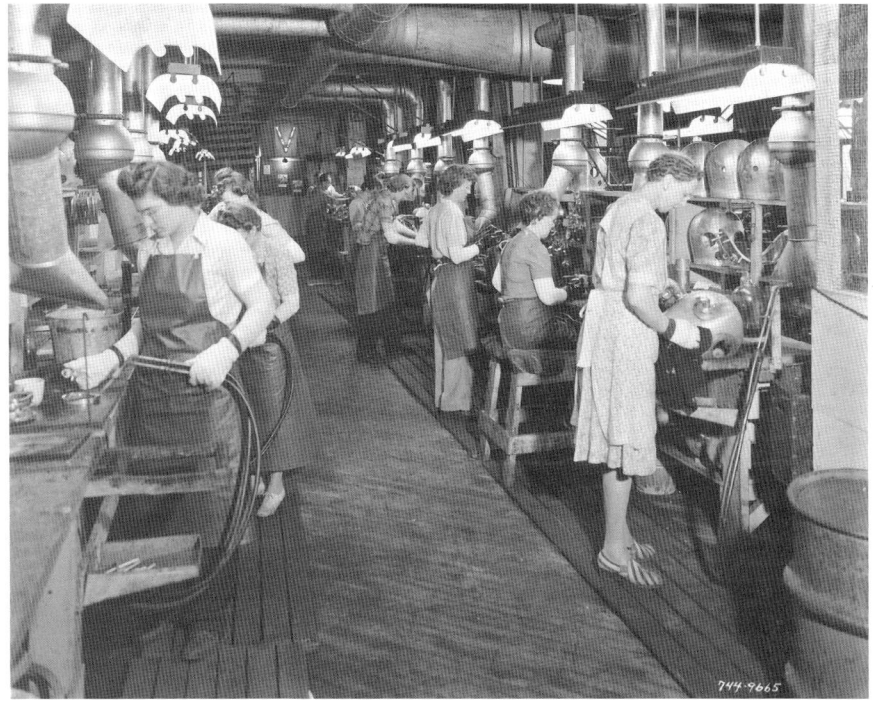

Women were hired at DESCO Corp. in Milwaukee to solder Mark V dive helmets and other equipment manufactured for U.S. Navy salvage divers. The company quickly expanded its workforce from 3 employees to 150, including many women hired to work on the soldering line. *Courtesy of DESCO Corp.*

of helium and oxygen. It took seven minutes to dive to that depth and seven hours to resurface to gradually and safely decompress. Mixed-gas diving has been routine for decades, but when Browne and End were testing their theories, it was revolutionary.

At war's end, most of the employees and practically all of the women were laid off as navy contracts dried up. One woman, though, stuck around. Bernice McKenzie saw a "help wanted" ad in one of the Milwaukee newspapers seeking defense plant workers in October 1942. When she showed up for an interview, McKenzie was told the opening was for a solderer. She had no experience, but the company needed to replace two female solderers who were leaving for other defense jobs. Those women trained McKenzie, who in turn trained other women who answered ads. Within six months, McKenzie had trained all eighteen women in the soldering department. Throughout World War II, McKenzie gained more responsibility as she moved throughout the

company, working in most departments. Eight years after she was hired, McKenzie became the company's vice-president.

McKenzie stayed at DESCO until retiring in December 1989. In a *Milwaukee Sentinel* profile in June that year, seventy-seven-year-old McKenzie told columnist Bill Janz that she was still soldering equipment, as well as answering calls from divers around the world. She recalled watching Browne dive to 550 feet in the pressurized tank in 1945.

"He was very adventurous. The day he set the [diving] record, we had more gold braid around here—the navy—and we had Russian people. It was very exciting," McKenzie said.

McKenzie also tested her company's products. In the mid-1950s, she dove in Lake Michigan outfitted in DESCO gear.

"The helmet weighed eighty-four pounds. The breastplate, a forty-five-pound belt and a pair of shoes that weighed twenty-four pounds. They shoved me off the rig," she said.

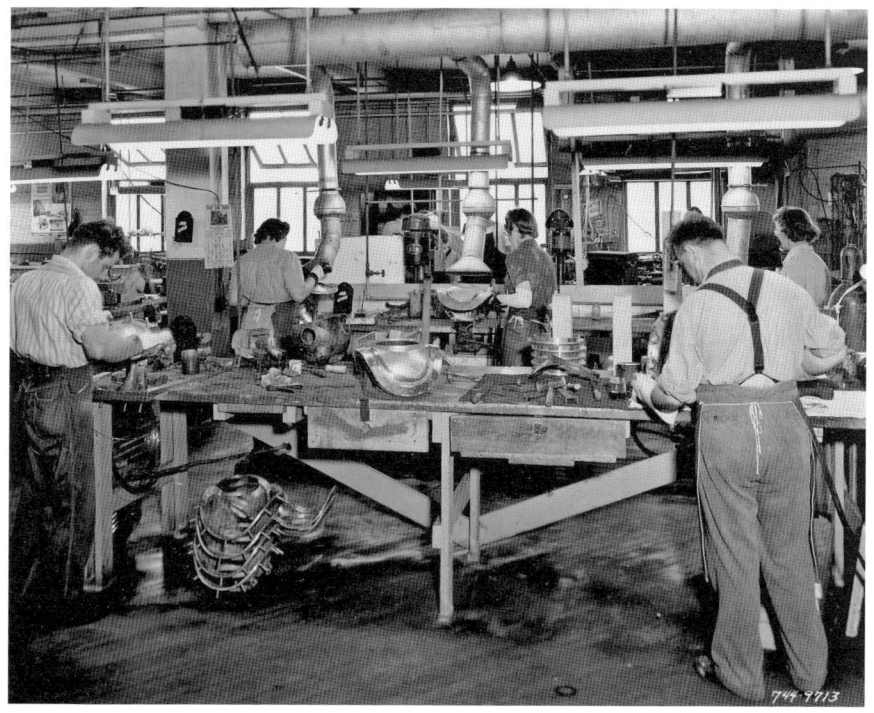

DESCO employees drill a dozen half-inch holes for studs on each Mark V helmet before sending the hard hats back to the soldering department. In the final stage of manufacture, workers wore white gloves to prevent oil on their hands from leaving black fingerprints on the gleaming helmets. *Courtesy of DESCO Corp.*

Nohl eventually returned to Milwaukee and opened a diving equipment company while still working as a technical advisor at DESCO. He salvaged a freighter that sank off Milwaukee's harbor in 1954; the *Prins Willem V* is still a popular wreck among local scuba divers, who call it the "Willie." Nohl's sister Mary, who gained her own fame as an eccentric folk artist, drew a comic strip based on her brother's life called *Diver Danny*. Mary Nohl's art-filled yard and house in Fox Point is listed on the National Register of Historic Places.

Nohl and his wife were killed in a head-on car crash in 1960 near Hope, Arkansas, the hometown of President Bill Clinton, while returning home from a vacation in Mexico. Killed in the other vehicle was R&B singer Jesse Belvin, who wrote the hit song "Earth Angel" and had just finished performing a concert in Little Rock with Jackie Wilson and Sam Cooke.

Browne sold DESCO in 1946 to the plant's general manager and a group of investors. He ran his family's car dealership in Milwaukee for several years and moved to Florida in 1950. He flew guns to Fidel Castro's forces in Cuba in 1958 and spent six weeks in a Cuban jail in 1963 when his scuba diving boat sank about one hundred miles north of Havana. Browne and eight other divers drifted for two days in a lifeboat before landing in Cuba and getting arrested. He died in 1998.

DESCO continues to manufacture Mark V helmets, around thirty-five a year, as well as a couple hundred air hats used for diving in contaminated water, with a workforce of six on the second floor of one of the oldest buildings in Milwaukee's Third Ward. The company refurbishes decades-old Mark V hard hats. And occasionally it makes dive helmets for films, including the diving rig worn by Cuba Gooding Jr. in the 2000 movie *Men of Honor*.

3
MILWAUKEE'S SINGING MAYOR JOINS THE FIGHT

Telegram messengers were not a welcome sight during World War II. At a time when a telegram was the fastest and most reliable way to get a message to someone, the Western Union delivery man was the last person anyone wanted to see in 1942, especially families with loved ones in harm's way.

At 3:50 p.m. on December 14, 1942, Clara Zeidler answered the doorbell at her home on North Thirty-third Street, ripped open the envelope handed to her by the messenger and read, "The navy department deeply regrets…"

A neighbor called Mike Zeidler at his barbershop on North Sixteenth Street, where a service flag with three stars—for his son Carl and for the sons of his two barbers—hung on a mirror. He rushed home to comfort his wife and read the telegram, which offered few details.

They were told only that he was missing. They were told not to divulge the name of his ship or his station. They later learned that by the time the messenger knocked on their door, their son's ship had been overdue for six weeks.

Carl Zeidler's parents would die without knowing exactly what happened to their son and without the chance to bury him. Carl's brother Frank later served as Milwaukee's mayor and for decades pressed the Pentagon to release information on his brother's death. Finally, in 1975, he learned his brother's fate.

Carl Zeidler was among thousands of Milwaukeeans to join the military in the weeks and months after the attack on Pearl Harbor. He didn't have

to. He was the mayor of the twelfth largest city in the country, running a community of 580,000 that was rapidly gearing up for war.

But Carl Zeidler, the grandson of German immigrants, felt a sense of duty. He thought he should serve his country in the military, not at his desk in city hall.

To some political observers, it was a surprise when Carl Zeidler actually moved into the mayor's office. Though he had made a name for himself as the assistant city attorney who drafted a controversial anti-pinball ordinance and prosecuted members of the German-American Volksbund, a pro-Nazi organization in Milwaukee, he was only thirty-two when he ran against Daniel Hoan, a popular socialist mayor who had served the city for twenty-four years.

His campaign staff arranged for him to speak at rallies and meetings, and he entertained voters by singing "God Bless America" in his robust baritone. Carl Zeidler had grown up in a musical family; he began singing in his paternal grandfather's band as a youngster and learned to play the violin. He was tall, handsome, charming and gregarious—and he could sing. Voters, especially women, were entranced.

Carl Zeidler did not announce his candidacy in a speech or issue a press release. At a campaign rally on a Saturday night in January 1940, he threw his hat in the ring backed by a five-piece jazz band, two female accordionists, three pretty women passing out campaign literature and a huge American flag that unfurled behind Zeidler right before he started to speak. And when he finished and stepped from behind the podium at an armory on Milwaukee's south side to shake hands, hundreds of balloons dropped from the ceiling.

A *Milwaukee Journal* reporter gushed, "For sheer political showmanship, Milwaukee perhaps has never seen anything quite like the formal opening of the Zeidler campaign."

His staff included a twenty-two-year-old struggling short story writer named Robert Bloch. Bloch had published stories in the pulp magazines *Weird Tales* and *Amazing Stories* before being hired, along with his friend and fellow Lincoln High School classmate Harold Gauer, to handle publicity and speech writing for Carl Zeidler's campaign. Almost two decades later, his novel inspired by Wisconsin's infamous murderer Ed Gein was turned into the blockbuster Alfred Hitchcock movie *Psycho*.

Bloch and Gauer each wrote autobiographies in the 1990s taking credit for the election of Zeidler, who had never run for office. They noticed that mayoral elections were boring, unglamorous affairs with candidates speaking to small crowds of followers in neighborhood meeting halls.

Milwaukee's Singing Mayor Joins the Fight

Milwaukee mayor Carl Zeidler signs autographs for a group of Oberlin College students in June 1940. Zeidler was assistant city attorney when he decided to run against longtime mayor Daniel Hoan. Known as the "singing mayor" because he frequently sang at city events, Zeidler served only two years before joining the U.S. Naval Reserve early in 1942. *Courtesy of the Milwaukee Public Library.*

"The difference would lie in the stunts and gimmicks we intended to dream up which would distinguish his [Zeidler's] gathering from those of rival candidates. In addition, the speeches we planned wouldn't be written for the audience in attendance. They would be designed to command newspaper stories read by eligible voters throughout the entire city," Bloch wrote in his 1993 memoir, *Once Around the Bloch: An Unauthorized Autobiography*.

Gimmicks included creating a plywood model of Milwaukee's city hall, which was wheeled out by a young woman when Zeidler told a crowd at a rally that nothing had been accomplished in the city under Hoan. As Carl Zeidler wielded a feather duster, a small cloud of dust—which was actually flour—rose from the model. When the candidate talked about lifting the lid on the mayor's neglect of the city, he lifted off the top of the city hall model, releasing paper moths activated by rubber bands.

World War II Milwaukee

When Carl Zeidler spoke about the need for a railroad depot, someone off stage tooted a railroad whistle. Carl Zeidler used his fist to smash a stack of cardboard boxes labeled "TAXES." He reached inside the city hall model and pulled out rolls of paper, which he said were plans for a train depot, city stadium and lakefront development, and threw them on the floor.

"None of these plans are worth the paper they are printed on, unless we get somebody in city hall who will give us action on them," he told the crowd.

Carl Zeidler spoke at rallies and meetings and on the radio. One of his speeches was translated into Polish, and a volunteer read it on Milwaukee's Polish-language station. Bloch noted that Carl Zeidler had two major areas of strength—youth and good looks—that could be used to appeal to voters.

"In those prehistoric, pretelevision times such qualifications were regarded as unnecessary," wrote Bloch, noting that half of Milwaukee's potential voters were women. "This good-looking young bachelor would naturally attract

Milwaukee mayor Carl Zeidler shakes hands with Fred Pabst at Pabst Brewing Co. on December 16, 1941, during the brewery's celebration of its two-millionth barrel of beer. After upsetting longtime mayor Daniel Hoan, Zeidler stayed in office only two years before joining the U.S. Naval Reserve. Less than a year after this photo was taken, Zeidler was killed when a German U-boat torpedoed his ship. *Courtesy of the Milwaukee Public Library.*

women's attention—and if we could provide him with campaign material designed to address their needs as working women, wives and mothers, we'd get votes which Hoan had ignored."

It worked. Carl Zeidler defeated Hoan by twelve thousand votes in April 1940. The national press took notice, referring to him as Milwaukee's new blond, baritone, bachelor mayor.

He became known as the "singing mayor"—he could sing in five different languages—and quickly threw himself into the job of running the city, attending meetings and public functions, handling appointments and responding to complaints and queries from citizens.

"He would charm people; it wasn't an act," said his niece Anita Zeidler, the daughter of Carl's younger brother Frank Zeidler. "He was just a sweet man."

She disputes the contentions by Bloch and Gauer that without their help, Zeidler never would have become mayor.

"Why did my uncle get elected? His sheer personality. My uncle showed up everywhere," Anita Zeidler said.

Anita Zeidler was born in 1944 and never met her uncle. But his photo was prominently displayed in her grandparents' home. Years after he was officially declared dead, Zeidler's parents refused to settle his affairs, believing he might still be alive and would one day walk through the front door.

Within months after the attack on Pearl Harbor, Carl Zeidler joined the military and was inducted into the U.S. Naval Reserve on April 8, 1942. A West Division High School graduate, he had served in the ROTC while he was a student at Marquette University, earning an undergraduate degree in 1929, followed by a law degree two years later.

At the Milwaukee Public Library, his archives amount to only a handful of boxes. This is not surprising considering he served such a short time before joining the U.S. Naval Reserve. Among the papers is a leave of absence notice on April 23 to the Board of City Service Commissioners for Carl F. Zeidler, 504 North Thirty-third Street, salary $12,300, who would be on leave without pay "for the duration of the war now being waged." His Naval Reserve pay represented a cut of around $10,000.

He continued his busy schedule right up until leaving. There are copies of letters revealing that he checked into the retirements of Milwaukee firefighters, responded to a petition to delay building an apartment on West Fairview Avenue, asked the common council to address the public transportation problem and OK'd the purchase of fifty trolley buses and forty-two gas-powered buses in 1942. There are responses to letters from people offering to help with the city's civil defense, from a man upset about

Milwaukee mayor Carl Zeidler poses for news photographers in his U.S. Naval Reserve uniform in front of city hall shortly before shipping out for duty on a Merchant Marine ship. Zeidler's ship was reported overdue in December 1942, and he was declared dead a year later. Decades after World War II, his brother Frank Zeidler, who served as Milwaukee's mayor from 1948 to 1960, finally learned Carl's fate. *Courtesy of the Milwaukee Public Library.*

Milwaukee's Singing Mayor Joins the Fight

a lack of security at Milwaukee's defense plants and from another man who was shocked that no one was guarding the ore carriers docked in the port. A January 27, 1942 letter from the Wisconsin National Guard asked for No Parking signs in front of its Milwaukee armory and mentioned that the mayor was the first to donate blood for the new War Department's blood plasma collection program in the city.

There were also letters sent to the mayor's office in January and February 1942 from several German groups in Milwaukee requesting that the mayor attend anniversary celebrations of a German American veterans group and a Bavarian dancing society, a performance of *Hansel and Gretel* by the youth section of the Federation of German-American Societies of Wisconsin and Washington's birthday observances of the Germania and German clubs in Milwaukee.

Within months, Carl Zeidler was fighting the Nazis.

"It was my uncle's decision. It was a decision of conscience," said Anita Zeidler. "People wrote to him asking, 'Why must my son serve? How about you? You're not married.'"

Efforts to persuade him to stay home were rebuffed by the mayor. The president of the Marshall and Ilsley Bank told a Milwaukee reporter that many citizens were disturbed by his decision to join the military. "In this kind of war, home morale, home defense and local industry are of paramount importance," said Albert S. Puelicher. "Because he has a tremendous following, Zeidler can do a unique job for his country as mayor."

There was talk of the mayor possibly being used by the military to sell war bonds. Articles in *The Milwaukee Journal* and *Milwaukee Sentinel* with headlines of "Mayor Deaf to Pleas He Stay on Job" and "Zeidler Bound to Go to Navy, Resists Pleas" reported that he met with navy commanders at the Great Lakes base in northern Illinois but did not ask for a specific job. Soon, Carl Zeidler learned his assignment: the Merchant Marine. Before he left, he posed for newspaper photographers in his blue uniform saluting in front of city hall, where large white letters spelled out "Good Luck Lieut. Zeidler" below the famous clock tower. When he left for training in Massachusetts, a crowd estimated at twenty thousand crowded Milwaukee's train station to say goodbye. He left Milwaukee on the second anniversary of his inauguration.

"He was a sensation for two years, and then he was gone. That was my uncle's ethics—he couldn't stay home," said Anita Zeidler, who still has her uncle Carl's violin, which she learned to play as a child.

Commissioned as a lieutenant junior grade, he was assigned to the steamship *La Salle*, where he was one of eight officers in a sixty-person crew

that included twenty armed guards. Zeidler was the officer in charge of the armed guard crew.

Carl Zeidler was unlucky. He was assigned to a Merchant Marine ship at a time when German U-boats ruled the seas, roaming shipping lanes in "wolf packs" that sank numerous vessels, killed thousands of sailors and sent vital equipment for the Allied war effort to the bottom of the ocean.

"What happened to those merchant ships early in the war—they were decimated. It bothered my dad," Anita Zeidler said. "My dad talked to him before he shipped out. He knew he wasn't coming back."

The *La Salle* left New York on September 10, 1942, loaded with 6,116 tons of trucks, steel, airplane parts and ammunition, stopping at Guantanamo Bay in Cuba and Balboa in the Panama Canal Zone. After it left Balboa on September 26, heading south along the west coast of Africa for Karachi, Pakistan, nothing further was heard from the *La Salle*. It simply vanished.

After the war, German U-boat records showed that the *La Salle*, which was sailing unescorted, was hit by one torpedo fired from *U-159* about 350 miles southeast of the Cape of Good Hope shortly before 11:00 p.m. on November 7, 1942. The U-boat had followed the *La Salle* for five hours and fired a stern torpedo, which missed, an hour and a half earlier. The sub surfaced to fire again. Though it's commonly believed that World War II submarines spent most of their time under water, in fact, the vessels could operate at depth for only relatively short periods of time. Many subs sank their prey while surfaced, where they could use deck guns without draining batteries needed to operate under water.

The second torpedo ignited the *La Salle*'s ammunition cargo, and the ship erupted into a fireball that shot into the air more than three hundred feet, the U-boat commander reported. The blast was reportedly heard three hundred miles away at South Africa's Cape Point Lighthouse. Wreckage rained down on *U-159* for several minutes after the torpedo strike, slightly injuring three German sailors on watch in the submarine's conning tower.

U-159 was in the middle of a 135-day patrol when it sank Carl Zeidler's ship, one of eleven vessels, almost all American and British, sunk by Captain Helmut Witte and his crew operating in the waters off Cape Town, South Africa.

For decades, Frank Zeidler tried to learn exactly what happened to his beloved older brother. It wasn't until the 1970s and '80s that he discovered through U.S. and German naval sources how the *La Salle* was hunted by *U-159*. He learned from the U.S. Coast Guard exactly where contact with the *La Salle* was lost: forty degrees south latitude; twenty-one degrees,

thirty minutes east longitude. From German sources, he saw a brief entry indicating a munitions ship was sunk at the same location.

Once Frank Zeidler knew the name of the submarine's captain, he began searching for his log. The Germans were very thorough, and after the war, detailed German military documents were delivered to the British. Frank Zeidler obtained a copy and in stark and heartbreaking detail finally learned about the last moments of his brother and fifty-nine other men on board the *La Salle*.

U-159 spotted the *La Salle* at 5:50 p.m. on November 7, 1942. Witte wrote:

> *1750 hours— Smoke veil 16 sea miles off. It is a great steamer with course 60 degrees. Through a favorable horizon I…can close before darkness, aiming at a stern attack if target remains clear.*
> *2000 hours (8 p.m.)—Shot out of (torpedo) Tube VI. Unexplained failed shot. It must be placed on torpedo failure since completely precise conditions underlay the shot.*
> *2250 hours—Shot out of Tube III. Fixed line first, shortly before shot on account of quick shifting of the goal. Munitions steamer, which when hit, was atomized. Burning column hundreds of meters high. Minutes long, it hailed broken pieces on the submarine, through which three men on the bridge were slightly injured. Upper deck injuries were little and will be taken care of…On the whole—much luck. Signed—Witte.*

Witte was among those injured. He wrote in his log that debris blasted into the air from the *La Salle* cut and bruised his left hip.

The German U-boat captain, who earned the Iron Cross Second and First Class, was reassigned in June 1943 to serve in German navy staff positions until the end of the war. He was lucky. One month after he left *U-159*, the German submarine was sunk in the Caribbean south of Haiti by depth charges dropped by an American plane. All hands were lost.

Witte died at the age of ninety in 2005.

The *La Salle*'s fate wasn't known for years, but military officials realized something had happened when the ship didn't show up to deliver its supplies in Karachi. On December 4, 1942, the U.S. Navy reported it overdue to Cape Town since November 1, adding it to a list of overdue ships presumed lost by enemy action. In mid-December, someone in Washington, D.C., typed a telegram that echoed thousands of other telegrams sent to worried families across the nation.

Carl Zeidler was still technically mayor since he had not resigned and was on military leave. One week after the telegram arrived at the Zeidler

home, acting mayor John L. Bohn, the common council president, issued the mayor's annual holiday greeting, something Carl Zeidler had done the previous two years. Dated December 22, 1942, Bohn thanked the common council, city officials and employees for their cooperation and harmony in the year since Pearl Harbor was attacked and noted that thousands of Milwaukeeans had joined the military just as Mayor Zeidler had done.

"Not content with the responsible wartime duties of his official position, Carl Zeidler felt the call of his country so strongly, that, at great personal sacrifice, he enlisted in the Navy," Bohn wrote. "As Lieutenant Zeidler, he commanded a gun crew in distant troubled water, but is now reported 'missing in action.' He is serving (I refuse to say 'he served' as long as there is hope that he may return) his country well and faithfully—a brave warrior and champion of democracy."

Bohn ended his message by saying he hoped Carl Zeidler and other Milwaukee residents serving in uniform would soon return home safely. The war, of course, lasted another two and a half years; the navy declared Carl Zeidler dead in November 1944.

All the Zeidler family could do was include his name on the tombstone for his parents at Forest Home Cemetery. The woman Carl Zeidler planned to marry when he came home from the war later joined the military and never married. Frank Zeidler, who was married with young children, nearsighted and suffered from heart problems from rheumatic fever, didn't serve in the military. He ran for Milwaukee mayor as a socialist in 1948 and served until 1960.

"All I remember as a child is learning the myth of my uncle," said Anita Zeidler. "The fact that he didn't come back meant he became an idea, not a person."

Carl Zeidler had much bigger aspirations than mayor of Milwaukee, his niece said. Had he survived and come home, he would likely have sought higher office and, as a charismatic war hero, might have ended up as Wisconsin governor. Or U.S. senator. Perhaps he would have run in 1946 against Senator Robert La Follette Jr., the son of Fighting Bob La Follette, who had represented Wisconsin in the Senate since 1925, when he was elected to the position after his father's death.

But La Follette Jr. narrowly lost the Republican primary in 1946 to a young circuit court judge who served in the U.S. Marines during World War II. It's interesting to speculate whether Carl Zeidler would have been Wisconsin's junior senator instead of Joe McCarthy. McCarthy became the powerful leader of the Permanent Subcommittee on Investigations, rooting

out Communists and suspected Communists while ruining the lives of the innocent and unwittingly lending his name to the ugly practice of accusing someone of treason without evidence.

One of the many victims of McCarthyism turned out to be La Follette. Six years after losing to McCarthy, La Follette committed suicide in Washington, D.C., after learning that while he was in the Senate, Soviet intelligence agents had served on his Civil Liberties subcommittee, including its chief counsel, John Abt. It's possible, though there's no way of knowing, that La Follette killed himself because he suspected he would be called to testify before McCarthy's committee.

4
THE HARLEY ON THE SUBMARINE

Submarines are cramped. Especially the subs that plied the seas during World War II. They were basically torpedoes where men lived and worked, forgoing all privacy and sharing sleeping bunks with whoever happened to work the opposite watch.

Pretty much everything on board World War II submarines was necessary to function as a fighting machine—engines, navigation and steering equipment, basic life support and, of course, torpedoes and ammunition for the top-side guns.

But Frank Latta managed to bring his wheels with him wherever he traveled as a submarine commander. Latta loved his Harley-Davidson motorcycle so much that he stowed it aboard the USS *Lagarto*, disassembling it each time he left port and putting it back together when the Wisconsin-built submarine arrived in port.

It wasn't surprising to see a Harley in far-flung locales. The company's product line already had a strong international presence before World War II, and through the Lend-Lease Act, Harley-Davidson motorcycles were among the tons of materiel shipped overseas to allies, including Canada, China, Brazil, France and Australia. Russia used more than twenty-seven thousand Harleys in the war. Most of the Lend-Lease motorcycles remained in the Soviet Union, China and Europe after the war; some are still running while others are prized antiques in collections.

Harleys manufactured for military use were not simply civilian models painted green or tan. First produced in 1940 and dubbed WLAs, they were the

World War II Milwaukee

The Harley-Davidson Co. manufactured more than eighty thousand military motorcycles during World War II with thousands sent to Allied nations under the Lend-Lease Act. WLA motorcycles featured heavier frames, thicker handlebars and Thompson machine gun scabbards. Headlights and tail lamps were equipped with metal blackout visors, ammunition boxes were attached to the front fork and special air cleaners reduced dust intake. *Courtesy of the Harley-Davidson Archives.*

more durable military equivalent of the civilian WL. The "A" stood for army. A similar version, the WLC, was manufactured for the Canadian military.

The WLA featured a heavier frame, lower headlights and thicker handlebar tubes compared to civilian models. Headlights and tail lamps were equipped with metal blackout visors and Thompson machine gun scabbards, ammunition boxes were attached to the front fork and special air cleaners reduced dust intake. Other accessories included leg protectors, skid plates and heavy-duty luggage racks to carry radios.

Harley motorcycles were used as fast, light transportation vehicles by military police to patrol bases. They were courier and dispatch vehicles. Some transported radio equipment. Like Humvees of the modern-day U.S. military, every military branch used them—armored divisions, quartermaster corps and other mechanized units. Unlike the German military motorcycles,

which were commonly equipped with sidecars, Allied cycles were rarely used for combat or to move troops and were mostly designed for single riders.

Because soldiers liberating Europe rode Harleys, they soon acquired the nickname "Liberator."

The company promoted the importance of its motorcycles to the war effort. An advertisement in the January 1943 issue of Harley-Davidson's magazine, the *Enthusiast*, read, "Rugged terrain, not paved roads, are the lot of the man who rides a motorcycle in the Army. They penetrate areas where other motor vehicles cannot follow."

Workers in Milwaukee produced more than eighty-eight thousand motorcycles during World War II, plus spare parts for another thirty thousand. They were shipped from the Milwaukee factory in export crates and assembled overseas by military mechanics, many of whom had gone to school at Harley-Davidson headquarters in Milwaukee. In 1941, the company converted its service school into a training facility for military mechanics. During month-long courses, students were taught how to keep motorcycles in fighting shape and to service Harleys with just a few tools in harsh field conditions. And those conditions could be brutal—extreme heat and cold, snow, mud, sand and drivers who threw down their vehicles when they came under attack or rushed to deliver messages.

While most production was switched to military vehicles, Harley-Davidson continued to make a small number of motorcycles for civilian use, primarily law enforcement. Acknowledging the difficulty in buying a new Harley, the company printed the following ad in its April 1942 edition of the *Enthusiast*: "The Harley-Davidson you had hoped to ride…is out at the front helping to win the war. We know you are glad to forego your new dream motorcycle so the brave lads in Uncle Sam's forces are equipped with the latest and the best."

National championships for hill climbs, track, road and endurance events were canceled in 1942 for the duration of the war, and Harley-Davidson factory tours were shut down because the government no longer wanted visitors touring the plant.

The monthly *Enthusiast* magazines, which featured cover photos of military members astride Harleys, became a way for motorcycle clubs to stay in touch with members who went off to war since soldiers, judging by the letters to the editor, continued to get their *Enthusiasts* no matter where they were stationed. The monthly roundup from Harley clubs throughout the country began to note that many members were serving Uncle Sam.

An example is the following dispatch from the Beaver Valley Motorcycle Club in Freedom, Pennsylvania, which reported in the June 1942 *Enthusiast*:

World War II Milwaukee

Field instructors teach students how to ride military models of Harley-Davidson motorcycles at the Milwaukee factory's U.S. Army quartermaster school in 1941. Tens of thousands of Harleys were sent overseas to U.S. and Allied military units and used as fast, light transportation vehicles by military police to patrol bases, as courier and dispatch vehicles and for transporting radio equipment. *Courtesy of the Harley-Davidson Archives.*

"We have lost most of our single men to the service and one we are especially proud of, Bob Mennell, who recently reported to the Flying Cadets at Santa Ana, California. He is our competition rider and one we are all very proud of and we all miss him. Every member in our club wishes Bob the best of luck and many happy landings."

Mennell survived the war. A March 2014 obituary from Chapel Hill, North Carolina, reported that Mennell, who retired as a lieutenant colonel, piloted B-24 Liberators in Italy and made the U.S. Air Force a career, including a tour of Vietnam in 1965. His obituary noted he was fascinated by engines as a boy and was an avid motorcyclist who owned an Indian motorcycle shop before World War II. He was ninety-two when he died.

A separate section of the letters to the editor were from service members. In "News from the Boys in Service," military members wrote to thank the magazine for reaching them:

The Harley on the Submarine

I was very pleased to receive the magazine because it seemed just like old times to read it again. There are several of my friends up here who are also motorcyclists. When they heard I had a late copy of the ENTHUSIAST *I was snowed under. We use Harley-Davidson motorcycles very extensively up here in Iceland and, believe me, they take a beating but they certainly can take it. Once in a while I have the opportunity to ride one again and, boy, just to twist that throttle gives me a thrill which is like flying. Having made three trips cross country by motorcycle back in the States, I am looking forward to the day when I will be able to make the fourth trip with a brand new Harley-Davison. Theodore C. Jack. Somewhere in Iceland.*

Private first class Orval A. Smith wrote from "Somewhere in France":

Over here I don't believe any other motorcycle could take the beating I've given three Harley-Davidsons since I've been a messenger overseas. A lot of folks wouldn't believe me if I told them of all the places I've gone through on the little old G.I. 45. I've ridden pavements, rocks and mud six inches deep, forded streams and ridden on ice, all the same day on runs delivering messages. Even jeep drivers might argue with me but I've gone lots of places that the versatile jeep couldn't go…One time Jerry [a nickname for German troops] *darn near finished me and my motor with one shell but as it was we just flew up in the air and I ended up in the hospital for a spell.*

The switch to military production was not foreign to the company. By the time World War II started, Harley-Davidson had already produced motorcycles used by combat troops dating back to the army's pursuit of Pancho Villa into northern Mexico in 1916, when the First Aero Squadron drove motorcycles equipped with machine guns mounted in sidecars. Motorcycles were sent to France and England for use in World War I to ferry wounded soldiers and carry dispatches. More than twenty thousand Harley-Davidson and Indian motorcycles—the same models sold to civilians—were shipped overseas during World War I. The school for military mechanics also grew out of World War I, evolving over the decades into Harley-Davidson University.

Gearing up for war before the attack on Pearl Harbor, Harley-Davidson began manufacturing a small number of WLAs in 1940. In addition to the machine that would end up becoming the workhorse of World War II, Harley-Davidson also designed motorcycles for desert terrain. The XA used twenty pounds more aluminum than the forty-five pounds in a WLA and was ultimately rejected when the Defense Department deemed the WLA

satisfactory. The company also designed the 1942 XS, which featured power and traction for driving in sand. But the XS was also destined to be a footnote when the army decided to use four-wheel-drive Jeeps and canceled the contract. Only three XS prototypes were built; the only surviving example can be seen in the Harley-Davidson Museum in Milwaukee.

With much of Milwaukee's male workforce in the military, Harley-Davidson began hiring women to run drill presses and lathes and inspect and package spare parts. The company sought permission from the Wisconsin Industrial Commission to employ women at night, and at the monthly meeting of the board of directors in July 1942, company co-founder William S. Harley suggested moving the frame shop out of the Juneau Street plant to another facility on Center Street to make room for female workers. The board also decided to seek advice about training and wages for female workers from other Milwaukee companies that employed

Harley-Davidson workers dip packages of motorcycle parts in wax for protection before shipping them overseas in August 1943. Harley-Davidson motorcycles were shipped from the Milwaukee factory in export crates and assembled by military mechanics, many of whom had gone to school at the company's headquarters in Milwaukee. *Courtesy of the Harley-Davidson Archives.*

The Harley on the Submarine

Sailors pose with a display touting Harley-Davidson's Army-Navy "E" Award at a U.S. Navy war bond rally at Milwaukee's lakefront in June 1944. Army-Navy "E" Awards were given for excellence in producing war equipment; they included pennants to hang at the factory in Milwaukee, as well as emblems for employees. *Courtesy of the Harley-Davidson Archives.*

women. The following month, the board voted to permit married women to work in the office for the duration of the war because of the labor shortage.

The firm was given Army-Navy "E" Awards for production excellence on war contracts in 1943, 1944 and 1945. A service flag signifying the number of employees serving in the armed forces hung from the Juneau Street factory. In 1944, the large service flag pictured a star in the center with "535"—the number of Harley employees serving in the military.

In 1941—when the company found it increasingly difficult to obtain enough aluminum because factories across the country were already gearing up for war—a total of 6,526 military motorcycles were manufactured. The following year, 13,051 WLA motorcycles and another 9,820 WLC vehicles rolled off the line, sold to the U.S. government for $369 apiece. By the end of June 1942, production had ramped up to a pace of 750 motorcycles each week, though within a few months that dropped to 675 because of shortages of steel, aluminum and rubber. Still, Harley-Davidson employees were churning out three times as many motorcycles as the previous year.

World War II Milwaukee

USS *Lagarto* captain Frank Latta astride his beloved Harley-Davidson motorcycle, probably in Hawaii in 1942 or 1943. Latta managed to take his Harley on board the submarine *Lagarto*, disassembling it and stowing it in pieces and then reassembling it when he arrived in port. Latta died along with his entire crew when a Japanese ship sank the *Lagarto* in May 1945. *Courtesy of the Latta family.*

By 1943, production had increased to 24,717 WLA and 2,647 WLC motorcycles, and in 1944, Harley-Davidson made 11,531 WLA and 5,356 WLC machines. As production wound down for military motorcycles in World War II, 8,317 WLAs were built in 1945. Throughout the war, motorcycle production averaged around 475 vehicles each week. The company also subcontracted work for other businesses, including Allis-Chalmers, producing thousands of truck winches, navy electrical switch box covers, B-29 aircraft fittings and shell parts.

While most of the Harleys ridden by American and Allied military members remained overseas after the war—some had never been taken out of their crates—returning GIs flush with cash became ardent Harley fans and bought military-surplus or new motorcycles.

Frank Latta was among the many Harley enthusiasts serving in uniform. But he didn't leave his motorcycle at home when he went to war. With the help of his machinist's mate, Frank Latta assembled his Harley when he came into a port.

On board the submarine USS *Lagarto*, Frank Latta was commander of a crew of eighty-five assigned to the ship as it was being built at the Manitowoc

The Harley on the Submarine

The USS *Lagarto* launches next to the Manitowoc Shipbuilding Co. on Lake Michigan on May 28, 1944. During World War II, the Manitowoc, Wisconsin company built twenty-eight submarines, which were sailed to Chicago and then floated in dry dock down the Mississippi River to the Gulf of Mexico. The *Lagarto* sank three ships in the Pacific before it was sunk by the Japanese near Thailand in May 1945 with the loss of eighty-six men. *Courtesy of the Wisconsin Maritime Museum.*

Shipbuilding Co. shipyard on Lake Michigan. Though it might seem odd to open a submarine manufacturing plant in the Midwest, Manitowoc, Wisconsin, proved to be a perfect spot. It was located on water, drew a large trained workforce from surrounding communities and was safe from enemy attacks that plagued ship works and other war plants along the East Coast and Gulf of Mexico.

Manitowoc Shipbuilding Co. built twenty-eight submarines during World War II, with twenty-five finished in time to see action, sinking a total of 132 Japanese ships. Once finished, they sailed south on Lake Michigan past Milwaukee's harbor and down to Chicago, where they entered rivers that ultimately led to New Orleans, out to sea through the Panama Canal and into the Pacific to battle the Japanese.

Named after the Spanish word for lizard, the *Lagarto* was launched in May 1944, just four months after its keel was laid, and commissioned in October. On its first war patrol, it sank a Japanese submarine and cargo vessel. The *Lagarto* was last heard from on May 3, 1945. Several weeks later, telegrams began arriving at the homes of the eighty-six men on board.

Among them was Frank Latta's home in California.

"I remember the mailman coming, but he came all the way up to the house—it was a long driveway—parking in front and knocking on the door. That was a bad sign," said Mike Latta, who was eight when his father vanished on the *Lagarto*. "I remember my mother freaking out. I was home writing a letter to my dad. It was a bad day."

Mike Latta, his younger brother and their mother moved to Manitowoc when the *Lagarto* was under construction, and as the captain's son, he was allowed to sail on two short test cruises on Lake Michigan. He fondly remembers sailors sliding their arms under his to help him through the submarine's hatches and up ladders to the conning tower. Mike Latta was sitting on the riverbank across from the shipyard on the day the *Lagarto* was christened and slid sideways into the water.

"When it went down, it sent up a huge wave. I remember people scurrying and running because a bunch of people got wet," Mike Latta said in a phone interview from Monterey, California.

Frank Latta was a gearhead who loved to tinker on vehicles and figured out a way to take his beloved Harley, believed to be a 1942 EL or FL, with him wherever he went. Mike Latta has only one photo of his father astride his Harley, most likely snapped in Hawaii. He doesn't know where or when his dad bought the motorcycle.

"I know he and the machinist's mate would tear it down to its basic parts and put the pieces in parts of the submarine where they would be out of the way and no one knew. They had R&R in Durban [South Africa], and when he got to a place like that, he'd bring it on deck, put it together and take off and go. It was his R&R."

After the telegram arrived with the news the *Lagarto* was overdue and likely lost, life went on for the families of the missing in action, including the Lattas.

Later, it was learned from a radio transmission of the Japanese minelayer *Hatsutaka* that it had sunk an American sub in the area where the *Lagarto* was on patrol in the shallow waters of the Gulf of Thailand. The *Hatsutaka* was sunk days later by the USS *Hawkbill*, another Manitowoc-built ship, whose commander was friends with Frank Latta. A *Hatsutaka*

life ring salvaged by the *Hawkbill* crew is in the archives of the Wisconsin Maritime Museum in Manitowoc.

Letters written by families of sailors aboard the *Lagarto* were returned, marked "undeliverable." They held out hope that the men were marooned on an island somewhere in the Pacific or possibly prisoners of war. The war ended. But nothing was ever heard from the *Lagarto*.

Until six decades later.

Thai fishermen had complained about their nets snagging on something, but it wasn't until a British diver looking for shipwrecks in 2005 discovered the *Lagarto* sitting upright in 236 feet of water, a huge hole punched in the side of the outer shell near the petty officers' quarters and forward torpedo room. The inner hull was dented in about 3 feet, and ballast and fuel tanks were damaged. No hatches were open, meaning in all likelihood that the crew is entombed inside.

The *Lagarto*'s rudder was turned hard to port and the dive planes set for a fast dive, which probably indicate the sub had just fired its torpedoes—the outer door to torpedo tube No. 4 was half open—and was fleeing a depth charge attack.

Frank Latta and his crew went down fighting.

The shipwreck is a war grave, all of the men believed to be entombed inside. Frank Latta's Harley, too.

Mike Latta was relieved to learn his father's final resting place had finally been discovered. He knew roughly where the *Lagarto* had gone down and had plotted the longitude and latitude on a nautical chart with the hope of one day sailing his boat there. After serving in the Peace Corps in Africa in the 1980s, he returned home via Singapore.

"I took a plane to Thailand, knowing it would fly over the area where he was lost. So I could say goodbye."

5

THE WORLD'S MACHINE SHOP RETOOLS FOR WAR

The LSTs that ferried soldiers and equipment to Omaha and Utah Beach on D-Day couldn't have unloaded their cargo without Falk Corp.'s gear drives allowing the amphibious ships to reverse direction in seconds.

Instrument panels on military aircraft, radar equipment and walkie-talkies used by soldiers to communicate on battlefields wouldn't have worked without Allen-Bradley's electronic components.

P-51 Mustang pilots escorting bombing missions over Europe couldn't have engaged in dogfights with German Luftwaffe pilots without propeller shafts made by Ladish Co.

Navy Seabees and army engineers couldn't have made landing strips on coral atolls, jungle clearings and desert sand dunes without Allis-Chalmers tractors and bulldozers, as well as large steel mesh mats manufactured by Milcor Steel in Milwaukee, which were unspooled over uneven terrain sometimes only minutes before military planes came in for landings.

A.O. Smith made casings for torpedoes shot out of American submarines and landing gear for the B-17, B-24 and B-29 bombers that destroyed German and Japanese cities. And the bombs dropped from those planes? Many were manufactured by A.O. Smith in Milwaukee, the largest bomb maker in the United States by the end of World War II.

It's true that many cities across the country quickly geared up to produce the equipment that helped the Allies defeat fascism, but Milwaukee was unique. The city that billed itself as the "Machine Shop to the World" didn't need to create sprawling defense plants on empty lots or import thousands of

An A.O. Smith employee stands next to bombs manufactured at the Milwaukee company. The second-largest defense plant in Milwaukee, A.O. Smith had made more bombs than any other U.S. company by the end of World War II. *Courtesy of the Milwaukee Public Library.*

skilled workers. The factories were already here along with plenty of skilled employees to operate machines, lathes, presses and other vital equipment needed to supply the war effort. Among the nation's largest cities at the outset of the war, only Detroit and Philadelphia had a greater concentration of their workforces involved in manufacturing.

Ships, motorcycles, tractors, combat boots and rifle straps, heaters for barracks, bombs, torpedo cases, plane and helicopter parts, artillery guns, aviation fuel tanks and parachute fabric were among the war materiel produced in Milwaukee, which rapidly expanded a workforce idled by the Great Depression. The city's manufacturing employment nearly doubled during the war, from 110,000 to almost 200,000 between 1940 and 1944. Many of those workers were women.

As women flooded into the workplace, companies scrambled to arrange for bathrooms and other accommodations. Women almost always earned less than men performing the same jobs and rarely served as union officers or as members of bargaining or grievance committees. With more women working in the war industry, Milwaukee bakeries reported a 15 percent increase in sales, which they attributed to female workers buying bread instead of baking loaves at home, Richard L. Pifer noted in *A City at War: Milwaukee Labor During World War II*. It was the same with lunch counters and clothing stores, which saw upticks in business, apparently because women no longer had much time to cook, pack lunches or make their own clothes. At least one Milwaukee laundry capitalized on the changing workforce by running ads urging busy women to drop off their dirty clothes.

Among the businesses vying for Milwaukee's pool of female workers were companies expanding production capacity as male employees were drafted or volunteered for the military. Plus, there were firms such as Briggs and Stratton, Cutler-Hammer and Globe-Union that already had large workforces of women. Many of those female workers lost their jobs when World War II ended as companies reverted to peacetime manufacturing and men returned home to reclaim their positions on assembly lines and factory floors.

Milwaukee's industrial heritage stretched back decades to the years following the Civil War when the city became a manufacturing center thanks to its location on Lake Michigan, as well as technological advances—railroad tracks linking Milwaukee to the Mississippi River and the growth of its harbor—that helped move raw materials and finished products. Milwaukee was a crossroads where millions of bushels of wheat, tons of flour and iron ore, acres of timber and herds of livestock passed through to be converted into products from steel and leather to plows and beer barrels filled with the

Kay Lamphear, twenty-one, operates a punch press at Allis-Chalmers's supercharger plant, machining diaphragm blades for aircraft engines. Allis-Chalmers was Milwaukee's largest defense employer during World War II with more than twenty-five thousand on its payroll at the peak of wartime production. *Courtesy of the Library of Congress.*

city's famous beverage before being shipped east and west. Those railroad tracks were later critical to the movement of raw materials, equipment and men during World War II.

By 1880, 45 percent of Milwaukee workers were employed in factories, the sixth-highest concentration in the United States. Many of the companies

that were so instrumental to the war effort in Milwaukee were businesses that opened their doors in the 1800s to make entirely different products. A.O. Smith was a machine shop founded in 1874 and specializing in bicycle frames and baby carriage parts. Allis-Chalmers, which employed Nikola Tesla for a few years after World War I, started in 1847 as a maker of flour-milling and sawmill equipment.

Those two companies would become the largest defense plants in Milwaukee. In July 1941, Allis-Chalmers employed 11,610 workers, and A.O. Smith had 6,499 on its payroll, according to Pifer's figures gleaned from weekly business columns in *The Milwaukee Journal*, which tracked employment, payroll and construction activity statistics. The next year, factory rolls skyrocketed to 20,632 at Allis-Chalmers and 8,594 at A.O. Smith, with more than 25,000 and 15,000, respectively, at peak wartime employment.

It wasn't just large Milwaukee companies that geared up for war; hundreds of smaller businesses and machine shops subcontracted for work. Among them was Milcor Steel Co. on Milwaukee's south side. Milcor was one of twenty-nine factories across the United States that produced quarter-inch steel planks ten feet long and eighteen inches wide. Pierced with holes to reduce weight, the deceptively simple jigsaw puzzle pieces called Marston mats made a huge difference in the war.

When thousands were locked together, they made a durable, all-weather landing strip for aircraft ranging from light fighters to heavy bombers on pretty much any kind of surface in both the European and Pacific theaters. Invented by a Pittsburgh Steel executive, the pierced steel planking was first field tested during U.S. Army Air Corps maneuvers in November 1941 near Marston, North Carolina. Among the units helping test the Marston mat was the Wisconsin National Guard's 126th Observation Squadron, which later became the 126th Air Refueling Squadron operating KC-135 Stratotanker refueling planes out of Milwaukee's Mitchell International Airport.

Initially, each mat weighed sixty-six pounds, but an aluminum alloy was later used to cut the weight in half. By the beginning of 1944, more than 180 million square feet of Marston mats, enough for 240 temporary runways, had been manufactured in Milwaukee and elsewhere. The military continued using Marston mats through the Vietnam War.

While many Milwaukee firms quickly switched production lines from civilian to war equipment, a few companies in the city were founded just weeks after the Pearl Harbor attack—like Froemming Brothers Shipyard, which built a couple dozen war ships right in the heart of Milwaukee.

World War II Milwaukee

Ben Froemming and his brothers, Walter and Herbert, started as a small road construction company in the 1920s. Operating out of a building on North Holton Avenue, Froemming Brothers eventually became one of the busiest paving contractors in the city and expanded to Texas, where the company built roads in several states and helped construct the U.S. airfield near the Panama Canal.

Realizing the navy was desperately short of ships needed for a war fought on two oceans, Ben Froemming traveled to Washington in December 1941 and arranged for an initial contract to build four seagoing tugboats at a cost of $1.2 million each. The only catch? Froemming Shipyard didn't actually exist. Not only was there no shipyard, but there were also no experienced shipbuilders on the payroll.

Ben Froemming was undaunted. He sent a telegram on a Sunday morning in December from Washington to one of his managers in Milwaukee. He didn't mince words: "We're shipbuilders. Get some men to work grading that dump yard."

He was referring to land on South First Street next to the Kinnickinnic River, which Ben Froemming had an option to buy before traveling to Washington. It was not difficult for a road-building company to turn ten acres of a former dump into a shipbuilding enterprise—dredging the river, driving piles, building a dock and erecting a fabricating shop and other buildings. Workers were hired and trained to build ships. Ben Froemming, a large man who played tackle on the Riverside High School football team, was blunt, telling a Milwaukee reporter, "What I know about shipbuilding you can stick in your eye. But I'll get me a couple of men who do know something about it."

He did hire a few experienced shipbuilders, and within six months the first tug was launched, sliding sideways with a big splash into the narrow river flowing into Lake Michigan. By September 1943, eight tugs had been built at Froemming Brothers, while four frigates were under construction. Workers who had never built ships quickly got up to speed, and production time was slashed from the normal one year for a seagoing tugboat to four months. At its peak, the shipyard employed 2,400, including electricians, painters, welders and plumbers. Froemming Brothers built twenty-six ships during World War II: four frigates named after cities, eight tugs named for famous lighthouses and fourteen cargo ships. Most of the ships were sent to the Pacific, including a few that earned battle stars like the frigates *Sandusky* and *Allentown* for service in New Guinea and Indonesia. Some Froemming ships ran supplies throughout the Philippines, between Pearl Harbor and

The World's Machine Shop Retools for War

Hundreds of people line up to watch a ship launch into the Milwaukee River next to Froemming Brothers Shipyard on South First Street. At its peak, the shipyard—which did not exist until shortly after the Pearl Harbor attack—employed 2,400, including electricians, painters, welders and plumbers. Froemming Brothers built twenty-six vessels during World War II, including frigates, tugs and cargo ships. *Courtesy of the Milwaukee Public Library.*

Guam and in the waters around Cuba. After the war, many of the ships built in Milwaukee were loaned to the Soviet Union or Japan, though one, the cargo ship *Doddridge*, was acquired by the Coast Guard and used as a radio relay ship for Voice of America broadcasts during the Cold War.

By the time the last ship left the Milwaukee shipyard in October 1945, Ben Froemming was gone. He was found dead of a heart attack in bed in his penthouse apartment at the Astor Hotel just days after atomic bombs were dropped on Hiroshima and Nagasaki. The forty-three-year-old company owner had attended a victory celebration at the Wisconsin Club the night before he was found. The last ship was named after Ben Froemming, and as soon as it launched, the company closed.

Integral to the navy's frantic pace of shipbuilding efforts in Milwaukee and elsewhere were gears required to push ships quickly through water—just the type of gears manufactured at Falk Corp. The company developed an inflatable clutch in the 1930s whose novel design allowed a ship to reverse direction in three to five seconds, Milwaukee historian

John Gurda wrote in a 1994 *Wisconsin Magazine of History* essay. Only three prototype inflatable clutches existed in 1942, when the navy hired Falk as its primary contractor for LST gear drives. Falk became the leading supplier of gear drives for American ships, from cargo freighters and aircraft carriers to destroyers and amphibious vessels. Falk workers produced more than 3,500 gear drives that turned propellers on 1,204 LSTs, 184 destroyers, 27 heavy cruisers, a dozen aircraft carriers and hundreds of transport ships, according to Gurda.

Allen-Bradley, which opened in 1901, when Lynde Bradley invented an adjustable resistor to control the flow of current to electrical machinery, supplied electronic components for a wide range of military equipment, such as aircraft instruments, during World War II. The company's motor controls were used in many defense plants throughout the country, allowing complex machine tools to operate more effectively. Allen-Bradley touted its efficiency in a 1942 advertisement: "These are times when split seconds count up. Multiply split-second savings by thousands of machine operations...and you get an extra bomber, several tanks and many more shells."

Like many Milwaukee companies, Allen-Bradley built new factory space and added on to existing facilities to accommodate three shifts working around the clock. Women accounted for around one-third of the workforce at Allen-Bradley, which increased from 550 workers in the 1930s to 1,300 during the war. Annual sales jumped from $4.2 million in 1940 to $15.4 million by the end of World War II.

At Allis-Chalmers, workers manufactured steam turbines, generators and electric motors for ships and other defense plants, artillery tractors, electrical switches and controls and superchargers that allowed aircraft to operate more efficiently at high altitudes. Allis-Chalmers made medium and heavy tractors flown to distant battlefields to tow artillery, level ground for roads and airfields, clear debris and construct fortifications. Soldiers, Seabees and marines in the Pacific prized multitasking Allis-Chalmers tractors for their toughness and versatility.

While many defense plant workers were ordered not to talk about their work at a time when factory lunchrooms sported "Loose Lips Sink Ships" posters, some of the more than twenty-five thousand Allis-Chalmers workers not only were forbidden to mention their tasks but also had no idea they were helping build the atomic bombs that would one day end the war. Allis-Chalmers played a critical and unsung role in the Manhattan Project, producing equipment and materials that were used to make the bombs dropped on Japan.

The World's Machine Shop Retools for War

Harriet Haberman left an office job to work on the assembly line at the Allis-Chalmers supercharger plant, where four out of five employees were women during World War II. *Courtesy of the Library of Congress.*

Starting in late 1942, Allis-Chalmers got the first of what would be more than sixty separate orders for the atomic bomb project, which included equipment designed and built for gaseous diffusion, the electromagnetic process that separated uranium, and large power plant equipment used to extract plutonium from uranium. While it was well known that scientists had succeeded in smashing the atom, few knew the complete picture of the efforts to harness that energy into a bomb that could end the war.

Among those in the dark were Allis-Chalmers workers and executives.

"The truth is, however, that at no time in those anxious years did any of us discuss the matter in terms of an atomic bomb," Allis-Chalmers vice-president Edwin H. Brown told *The Milwaukee Journal* in January 1946. "Our suspicions and then our convictions were never put into words. It was something we thought about but never expressed."

Movement was restricted. Employees were allowed only into their workstations. Some areas were walled in. General Leslie Groves, the director of the Manhattan Project, was a frequent visitor.

A new building was constructed at the large Allis-Chalmers plant to manufacture the atom-sorting machinery used for gaseous diffusion. That method involved a system of cascading pumps and semi-permeable membranes used to separate isotopes, requiring machinery built by Allis-Chalmers, which Brown called "an extremely difficult manufacturing operation in which all our resources were employed."

For electromagnetic separation, scientists figured five thousand tons of copper were required to create a huge magnetic field to deflect charged particles. But copper was in short supply. So silver was used—six thousand tons of silver bullion transferred from the U.S. Treasury to the factory in West Allis, where forty-foot-long, half-inch-thick strips were wound onto magnetic coils and shipped to Oak Ridge, Tennessee.

"The total value of the silver sent here was $100 million. It came in straps, about two inches wide," said Brown. "The route taken from Fort Knox was never twice the same, and you may be sure that the guards—they were treasury men on special detail—were even more watchful than all the others."

Silver sawdust on the factory floor was painstakingly swept up. After the war, all machinery was dismantled and cleaned; even the wooden flooring under machines was removed and burned to recover the tiniest particles of silver to be returned to the government.

Brown bragged to *The Milwaukee Journal* that Allis-Chalmers contributed the most equipment by weight to the atomic bomb program than any other company. Grateful Manhattan Project officials sent Allis-Chalmers executives a souvenir—a small chunk of melted and fused dirt picked up from the Trinity test site in New Mexico. Brown kept it on his desk to show to the journalist, who reported in the last paragraph of the story that engineers tested it and discovered it still possessed a considerable amount of radioactivity.

Milwaukee's second-largest wartime employer, A.O. Smith, had developed a technique for manufacturing bicycle frames out of tubular steel instead of solid iron bars in the late 1800s. By 1910, the company was the biggest manufacturer of automobile frames in the country. In the First World War, A.O. Smith produced thousands of 75- and 150-pound bomb casings, developing an improved method of arc welding that accelerated production.

With America at war a second time, the company resumed bomb production, processing 3,500 miles of welded steel pipe into five million bombs ranging from five hundred pounds to forty-four thousand pounds. A.O. Smith workers developed torpedo flasks for the navy; built landing gear for B-17, B-24, B-29 and C-47 aircraft; and welded steel propeller blades for

The World's Machine Shop Retools for War

In addition to building landing gear for the B-17, B-24, C-47 and B-29 aircraft, A.O. Smith workers welded steel propeller blades for P-47 Thunderbolts and other fighter planes. By the end of 1945, A.O. Smith had produced 46,700 propeller blades for military aircraft. *Courtesy of the Milwaukee Public Library.*

P-47 Thunderbolts and other fighter planes. By the end of 1945, A.O. Smith had produced 46,700 propeller blades for military aircraft.

Half a century later, A.O. Smith was pivotal in a unique rescue of a World War II casualty.

In July 1942, a squadron of B-17 bombers and P-38 fighter planes flying from the United States to Britain encountered bad weather that iced up their wings and windshields, forcing the crews to ditch their aircraft in Greenland. Though the crews were rescued, the planes—two B-17s and six P-38s—were left behind on the ice.

Lockheed manufactured more than ten thousand P-38 Lightnings, but nearly all of the planes that survived World War II were destroyed or quickly made obsolete by faster fighters. Eventually, that made the P-38s left behind in Greenland very valuable—so valuable that aviation enthusiasts spent years looking for them, figuring their olive drab twin tails were probably sticking out of the ice and that searchers only needed to brush off the snow, fill fuel tanks and fly them back to the United States.

It turned out to be quite a bit more difficult.

The squadron was eventually discovered in 1992—under 268 feet of ice. A crew of aircraft restorers burrowed down; disassembled one of the P-38s, which was quickly dubbed "Glacier Girl"; and clawed the parts from Greenland's grip. The pieces, including guns still loaded with ammunition, were carefully brought back to daylight over fourteen weeks, wiped clean and then restored over the next decade. To reach Glacier Girl, the crew used a process called cold mining, boring a hole through solid ice and then using a hot water cannon to carve a 50-foot-wide cavern around the plane for rescuers to work.

The primary hot water source came from a boiler manufactured by A.O. Smith.

6
MILWAUKEE'S NAZIS

The red, black and white jagged symbol of hatred fluttered in the breeze next to tents filled with boys sent to summer camp by their parents. The youths swam, fished, played sports, marched in formation, performed calisthenics and started each day with a flag-raising ceremony.

The youth camp was neat and clean, with a sign at the entrance that read, "*Bitte das Camp in ordnung halten. Abfaelle in die Koerbewerfen,*" reminding campers to keep the place in order and throw their garbage into wastebaskets.

Despite the Nazi flag and a banner with double lightning bolts that would later strike terror as the insignia on German SS uniforms (and warrant a separate key on typewriters in Nazi Germany), counselors insisted the camp was harmless and that it was simply a fun place for young boys to spend a few weeks in the country, much like the Nazi youth camps spread throughout Germany.

But Camp Hindenburg was not in Germany; it was in Wisconsin, about twenty-five miles north of Milwaukee in Grafton. And many of the campers frolicking in the Milwaukee River were the sons of German-American Volksbund members living in Milwaukee and Chicago.

In a state with such a heavy concentration of residents with German ethnicity, it wasn't unusual to have a large number of German heritage organizations. But while most were benign groups of German immigrants or second and third generations, the German-American Volksbund was not. What started in the mid-1920s as the Free Society of Teutonia, one of the first Nazi organizations to appear in the United States with

small units in a few cities, including New York, Detroit and Milwaukee, morphed into the Friends of New Germany in 1933. Three years later, it was renamed the German-American Volksbund, or simply Bund—the German word for alliance.

Bund rallies in Milwaukee in the late 1930s featured Nazi flags and salutes; speakers railing against Jews and Communists; uniformed, brown shirt–clad members of the *Ordnungsdienst* (the militant faction of the Bund); fistfights; hecklers; protestors; and arrests. While Bund leaders claimed there were thousands of members, from most accounts, it appeared membership in Milwaukee was at most five hundred people. Bund rallies in Milwaukee drew members from throughout the Midwest.

A front-page headline in *The Milwaukee Journal* in February 1938 read, "Fists Fly, Glass Crashes at Bund Meeting," with a photo of a heckler getting tossed out by Milwaukee police and the caption: "The German-American Volksbund meeting of pro-Nazis at the Auditorium Saturday night ended in a free-for-all that not even the photographer escaped." The *Journal* cameraman was about to lose his photo equipment to a storm trooper before police stopped the Ordnungsdienst member as he reached for the camera.

More than 350 picketers showed up at that Bund rally honoring George Washington's birthday at Milwaukee's Auditorium, where a crowd estimated at 300 had come to hear speeches by national Bund leader Gerhard Wilhelm Kunze and the Bund's Midwest leader, George Froboese, who lived in Milwaukee. An orchestra played German music, waitresses carried glasses of beer to Bund members sitting at tables covered with red and white tablecloths and a dance floor was set up like a traditional beer garden. Bund members stood to sing the German national anthem, their arms raised in the Nazi salute. Kunze told the crowd that Bund members were building a bridge between America and Germany. He also spouted the same hateful rhetoric spoken by Nazis in Germany, claiming that the Bund was against "indiscriminate intermixture of the Aryan race with other races. Our symbol, which has been objected to, can be used in any country by white gentiles who want to unite in the common fight against international Marxist communism. Why cannot we use that symbol? The flags of other countries are displayed in this country."

Outside the Auditorium, protesters carried signs: "Hitler's Bloody Whelps Not Wanted in Milwaukee," "Drive Hitler's Stooges Out of Milwaukee," "Kunze Scouts for Hitler's Army" and "Outlaw the Bloody Nazi Bund."

A scuffle broke out when Froboese announced that anyone who wanted to question Kunze had to do so outside the hall. Some protesters were

badly beaten, one man's teeth were knocked out, six hecklers were arrested and rocks were thrown through the glass windows of Kilbourn Hall inside the Auditorium.

Froboese indignantly pointed out to a *Milwaukee Journal* reporter that a Nazi flag had been torn down from the Auditorium balcony the night before at the end of a six-day indoor bicycle race. Two men were seen loosening ropes holding a large swastika banner from the west balcony before it dropped to the ground, leaving a gap between two American flags. On the same night, a twenty-four-year-old Milwaukee man named Fred Raikovich admitted to stealing a Nazi flag from the equipment case of two German bicyclists and then trying to flush it down a drain in the men's room when a police officer arrested him. He was charged with disorderly conduct and fined five dollars.

Before the Washington birthday Bund rally in 1938, the Milwaukee-based vice commander of the Army-Navy Union asked the Auditorium's board of directors to cancel the rally. In a letter to the Auditorium board, Mortimer Kastner wrote:

> *In view of the aggravated condition of world affairs, I believe it to be fully within your discretion to discourage the introduction in Milwaukee of these alien doctrines which are so detrimental to the orderly administration of our own affairs. Should you find no way of eliminating these obnoxious activities please consider the fumigating of the Auditorium premises.*

Violence erupted again a month later when Communists rushed the stage during a Bund rally in Milwaukee. The summer before, a Bund rally in Kenosha had drawn four hundred people and one hundred protesters to the German-American Club house. Bund members from Milwaukee, Sheboygan, Chicago and Indiana attended and listened to Froboese rant against the enemies of Germany, vowing to fight to the "last ounce of blood in our veins."

When Camp Hindenburg opened in 1937, *The Milwaukee Journal* sent a reporter and photographer for a visit. Before they were allowed into the camp, though, they needed permission from Froboese to speak to camp leader Karl Moeller. In a story published on July 23, 1937, the *Journal* reporter noted that the counselors and boys spoke German, orders were given only in German, signs around the camp were written in German and Nazi emblems were seen fluttering in the breeze, though always under an American flag.

A few days before *The Milwaukee Journal* visit, a Democratic senator from Connecticut, William M. Citron, had demanded an investigation of Camp Hindenburg and sixteen other youth camps across the United States that he called Nazi military training camps. And the secretary of the anti-Nazi League in New York demanded to know who was financing and directing the camps.

In response to Citron and the anti-Nazi League secretary, Froboese told the *Journal* that the German government was not trying to train young Nazis in America.

"Those charges make me laugh. These men are just trying to stir up trouble by making charges they know are not true," said Froboese.

At Camp Hindenburg, Moeller denied that any military activity was taking place and said that the 103 boys, who included 30 from Milwaukee, played baseball, swam and had regular inspections but did not perform military drills. When asked about a Nazi flag flying at the camp, Moeller explained that one of the campers had brought the flag back from Germany and camp management "just didn't have the heart to keep him from displaying it."

"Our youth movement has no connection with the German youth movement," Moeller insisted to the *Journal*. "The Boy Scouts of America cannot say the same. The scouts are an international organization and their leader and founder, Lord Baden-Powell of England, is an alien so far as this country is concerned."

Camp Hindenburg was short-lived. It was transformed into Camp Carl Schurz in 1939, when a coalition of German American groups leased the land, naming it after the first German-born American elected to the U.S. Senate. Carl Zeidler was among the speakers who visited Camp Schurz in 1939 before running for Milwaukee mayor. The Wisconsin Federation of German-American Societies had earlier distanced itself from the Bund, releasing a statement in 1938 saying that it had nothing in common with the racial hatred and religious intolerance fostered by the group. When Camp Carl Schurz was opened, the Wisconsin federation said children would be taught American values, and the only flag flying over the camp would be the Stars and Stripes.

Volksbund officials found another site one mile south of Camp Carl Schurz to open a camp for their children. Claiming the original site had been stolen from the Volksbund, Froboese said, "I am glad they had the decency to abandon the name Camp Hindenburg."

Later that summer—one week before Germany marched into Poland— Froboese was quoted in the *Milwaukee Sentinel* boasting that the non-aggression

pact signed with the Soviet Union "was a master stroke of diplomacy. Heretofore the English and the French were in Moscow trying to get a pact with Russia and Germany slipped right in ahead of them." Froboese also claimed the threat of war in Europe had been eliminated by the pact with the USSR.

Froboese and other German-American Volksbund leaders met Hitler when they traveled to Germany in 1936 for the Berlin Summer Olympics. But Nazi officials quickly distanced themselves from the Volksbund, and the German ambassador to the United States voiced his concerns that the group was embarrassing Germany. The Nazi government announced in March 1938 that the German-American Volksbund was barred from using Nazi emblems, and Germans living in America could not join the group. One year later, six months before Germany invaded Poland, a Bund rally at Madison Square Garden in New York drew more than twenty thousand people. Like the rallies in Milwaukee, fighting erupted between hecklers and three thousand Bund storm troopers. In a speech to the crowd at Madison Square Garden, Bund leader Fritz Kuhn stood in front of a large portrait of George Washington and Nazi and American flags while repeatedly calling President Franklin Roosevelt "Frank D. Rosenfeld" and labeling the president's New Deal "the Jew Deal."

The Madison Square Garden rally turned out to be the peak of Bund activities in the United States. Not long after his incendiary speech, Kuhn was arrested for embezzling thousands of dollars from the Volksbund, though it was New York district attorney Thomas Dewey who sought charges and not the Volksbund, which operated under the principle that, like Hitler in Germany, its leader had absolute power. Kuhn, who was born in Germany and fought in the Bavarian infantry in World War I before immigrating to the United States and becoming an American citizen, was sentenced to prison for tax evasion and embezzlement. As soon as he was released from prison in 1943, he was arrested again, as an enemy alien, and interned at a federal camp in Texas before being deported to Germany two weeks after the end of World War II. He died there in 1951.

Kunze, who spoke at the 1938 Milwaukee rally, fled to Mexico in November 1941 to avoid being drafted in the U.S. Army. His defection elevated Froboese to national leader of the German-American Volksbund on November 13, 1941. Born in Hanover, Germany, in 1900, Froboese immigrated to Milwaukee in 1922 and became a citizen in 1934, working for a time as a mechanical engineer at Nordberg Engineering Co. and writing a book about the Volksbund.

The group's days were numbered when Germany declared war on America four days after the attack on Pearl Harbor. Federal agents seized Bund records, and members faced deportation and imprisonment. In June 1942, Froboese was subpoenaed to testify about Bund activities before a New York grand jury. The *Milwaukee Sentinel* reported that Froboese had been investigated openly and secretly for years, questioned, shadowed, picketed, booed and threatened. Now, FBI and immigration officials were trying to get Froboese denaturalized on the grounds that he had been untruthful when he renounced his allegiance to Germany and became a U.S. citizen. If that happened, he would likely be interned for the duration of the war.

On June 15, 1942, Froboese's wife told police her husband left their home on Port Washington Road to take a train to New York. But Froboese never testified to the grand jury and never arrived in New York.

Instead, he got off the train at the small railroad junction of Waterloo, Indiana, that evening and, around 10:30 p.m., laid his head on a track and waited for an oncoming train. Froboese's "neatly decapitated" body, as the *Milwaukee Sentinel* reported, was found just after midnight with the grand jury summons in his pocket.

7
THE NAZI RESISTER

Mildred Fish Harnack spent her last hours tracing the words of the poem Walt Whitman wrote about President Lincoln's assassination, "When Lilacs Last in the Dooryard Bloom'd," using a tiny pencil smuggled to her as she waited to walk to the guillotine in Plötzensee Prison in Berlin.

Five months before February 16, 1943, Mildred had been a vivacious, beautiful blonde, but by the time she was led to the same room where her husband, Arvid Harnack, had been slowly strangled on a meat hook a few days before Christmas, she was a stooped, white-haired woman who looked much older than her forty years.

The Milwaukee native initially avoided the fate of her husband and others with whom she worked in the anti-Hitler underground resistance organization the Nazis dubbed the Red Orchestra. She was originally sentenced to six years in prison for her role in attempting to undermine the Nazi regime and end the war.

But when Adolf Hitler learned of the verdict, he ordered her to be tried again, with the only outcome of the new trial to be a death sentence. Mildred Harnack was the only American civilian woman killed on direct orders of Hitler.

In many respects, the deaths of Mildred, her husband and dozens of others in the Red Orchestra were pointless. Nazi battle plans and other secrets they passed to the USSR, including Hitler's intention to invade the Soviet Union despite the countries' non-aggression pact, were discounted by Stalin. The Russian dictator was incredulous that Germany would attack,

Mildred Fish Harnack visits a lakeside resort in northern Germany in 1938. The Milwaukee native was arrested in 1942 for participating in the Nazi resistance group the Red Orchestra. She was the only civilian American woman executed on direct orders of Adolf Hitler. *Courtesy of the German Resistance Memorial Center.*

and he believed Hitler's lie that German troops massing at the Soviet border were part of an invasion force for Britain.

The trials of Red Orchestra members in the fall of 1942 coincided with the German army's losing battle for Stalingrad, a debacle that would cost a quarter million German lives. Rather than blaming themselves for a foolish attack that eventually bogged down in the brutal Russian winter, Hitler and his generals used the Red Orchestra as a scapegoat for their stupidity. It was easier to blame the setback on a vast Communist conspiracy in Berlin than to point the finger at Luftwaffe chief Hermann Goering, who couldn't keep his promise to supply beleaguered troops by air, or at Hitler, who turned down his generals' frantic requests to retreat. Instead, Hitler decreed that his soldiers must stay in Stalingrad and fight to the last man—which they did, losing practically the entire Sixth German Army, as well as one thousand tanks, numerous planes and 1,800 artillery guns.

After the war ended, the courage and sacrifice of the Red Orchestra were treated with contempt. Because many were Communists, their

actions were somehow not as noble as other resistance movements in Germany, something Mildred Harnack biographer Shareen Blair Brysac called a "curious double standard." To many in Germany in the decades after the war ended, Mildred Harnack and others in her group were traitors because they passed secrets to Soviet intelligence. They were not considered patriots who tried to end the war and stop Hitler like other resisters working in Germany, such as Claus von Stauffenberg, leader of the July 20, 1944 failed assassination attempt on Hitler. When many Red Orchestra members were executed in late 1942 and early 1943, the Soviets were allies of America and Britain, but that quickly changed as the Cold War turned wary friends into ideological enemies. By 1947, families and acquaintances of those imprisoned or murdered by the Nazis became suspect in anti-Soviet West Germany, where many former Nazis were recruited by America and Britain to work for the new West German intelligence services. Behind the Iron Curtain, the Red Orchestra was all but forgotten because the Russians didn't want to draw attention to their espionage operations in Germany.

Mildred Harnack was the only American in the Red Orchestra to die, and yet an official inquiry into her death by the U.S. Army's War Crimes group was quietly closed in late 1946 after several months of investigation. American military investigators concluded that the two secret trials and Mildred Harnack's death sentence were justified—even though she was tried without defense witnesses and Gestapo agents who testified against her obtained their evidence through torture.

"Ponder the remarkable implications of this judgment," wrote Blair in *Resisting Hitler:*

Mildred Harnack's last-known photo, taken by the Gestapo in the autumn of 1942 following her arrest, along with other members of the Red Orchestra, including her husband, Arvid. Before she was beheaded by the Nazis in February 1943, her last words were: "And I have loved Germany so much." *Courtesy of the German Resistance Memorial Center.*

Mildred Harnack and the Red Orchestra. "One set of lawyers working for the U.S. Army upholds the judgment of another set of lawyers working for Hitler's Reich and concludes that 'the highest state military court' was 'justified' in ordering the beheading" of Mildred Harnack.

Months after Mildred Harnack was killed, her hometown newspapers picked up a report from Bern, Switzerland, that her husband had been hanged and their possessions confiscated for "Communist reasons." In a May 18, 1943 article in *The Milwaukee Journal*, she was called "the Milwaukee born woman upon whom the wrath of the Nazis is reported to have descended following the execution of her husband for treason." Her sister Marion Carlson, who lived in Wauwatosa, told the *Journal* she had not heard from Mildred since the previous August, but she planned to try to reach her through the Red Cross. Carlson wouldn't learn for several months that her sister had been dead since February.

Carlson said her sister had never expressed any opinions about the Nazis in letters and was reluctant to discuss German politics during a 1937 U.S. lecture tour that included stops in Wisconsin. University of Wisconsin–Madison assistant professor of English Ruth Wallerstein told the *Journal* reporter that she remembered Mildred as a distinguished poet who discussed only literature when she visited the campus on that lecture tour.

"I am sure, though, that neither my sister nor her husband was a Communist," said Carlson. "It sounds to me like a trumped-up reason the Nazis have given."

Mildred and Arvid Harnack were Communists. Mildred's political leanings did not bloom until she met the handsome German exchange student at the University of Wisconsin. Her relatives later attributed her left wing views to her years in Madison, where questions of class and social problems interested her.

Before she left for Madison, Mildred Fish was a Milwaukee girl, born and raised in the city, attending West Division High School, now Milwaukee High School of the Arts, a decade and a half after Associated Press Berlin bureau chief Louis Lochner graduated from the school and a few years before Carl Zeidler enrolled. The youngest of four children, Mildred grew up swimming in the Milwaukee River in the summer and ice-skating on her family's flooded yard in the winter. The Fish family lived modestly, occasionally renting out rooms and taking in boarders as Mildred's feckless father moved through a succession of jobs that included insurance agent, teacher, clerk and salesman.

She enrolled at the University of Wisconsin in 1921, working her way through college to pay for tuition and expenses. Mildred was a drama and

The Nazi Resister

Mildred Fish on a trip to Niagara Falls with her mother in September 1921 when she was eighteen or nineteen. Mildred grew up in Milwaukee, attended West Division High School and earned bachelor's and master's degrees at the University of Wisconsin–Madison, where she met her husband, Arvid Harnack, a German exchange student. *Courtesy of the German Resistance Memorial Center.*

music critic for the *Wisconsin State Journal* during her freshman year. She was a contributor to the *Wisconsin Literary Magazine*, excelled in the classics, wrote her senior thesis on *The Iliad* and loved Walt Whitman and Ralph Waldo Emerson because, in her mind, they managed to capture the essence of America. After earning her undergraduate degree, Mildred was teaching at UW in 1926 when Arvid Harnack mistook Bascom Hall for Sterling Hall and walked into the wrong lecture. He was mesmerized by the tall blonde with the mellifluous voice and stayed to listen. As students filed out at the end of the class, Arvid apologized for interrupting Mildred's lecture. He also apologized for his poor English. Mildred replied that her German wasn't good either. They agreed to meet again.

Arvid Harnack, one year older than Mildred, came from a family of academics in Germany. After law school, he traveled to Wisconsin in 1926 as a Rockefeller scholar, eventually earning his doctorate back in Germany with a thesis on the pre-Marxist workers' movement in America based on his research at the University of Wisconsin. By then, he and Mildred had married at her brother's farm in Brooklyn, Wisconsin, southeast of Madison. It appears they quickly fell in love, frequently paddling a canoe out to Picnic Point on Lake Mendota, hiking and reading to each other, their English- and German-language skills improving as they spent more time together. He introduced her to Goethe; she introduced him to Whitman and Emerson. They were well-read intellectuals who drew like-minded people into their orbit, inviting students and faculty to their home to read Shakespeare and attending "Friday Niters"—picnics, meals, discussions and debates with other liberals on the Madison campus eager to talk about philosophy, politics and current affairs.

Among them was Greta Lorke, a graduate student from Germany who met Mildred and Arvid while sailing ice boats on frozen Lake Mendota. She later returned to her homeland and married Adam Kuckhoff, a playwright and writer. The Kuckhoffs remained friends with the Harnacks and joined the Red Orchestra. In the hopes of spreading the word of the threat Hitler posed to the world, Greta Kuckhoff translated Nazi speeches and articles on racial policy into English and worked on the English translation of *Mein Kampf*. Adam Kuckhoff, like Arvid and Mildred Harnack, was executed by the Third Reich for his participation in the Red Orchestra. Greta Kuckhoff was originally sentenced to die for her participation in the resistance movement but spent several years in prison, surviving the war and living in East Germany, where she was president of the Deutsche Notenbank in the 1950s. She spoke at the dedication of the Mildred Harnack High School in East Berlin in 1976.

"I knew that Mildred loved the beauty of her Midwestern home with its brightly colored fall. She also loved the exuberant language of the new American writers," wrote Greta Kuckhoff, who died in 1981.

When Arvid's fellowship ended in 1928, he returned to Germany while Mildred moved to Baltimore to teach English. Within a year, she was chosen for a fellowship in Germany and sailed to her husband's homeland in the summer of 1929. Germany would be Mildred's home for the rest of her life.

Shortly after Mildred left America, Wall Street crashed, and as the United States sank into the Great Depression, Europe's weakest economy collapsed. Germany was still staggering under the weight of reparations from World War I, and as U.S. banks closed, Americans began calling in foreign loans. Extreme poverty soon followed in Germany.

Brysac wrote:

> *Along with Arvid, Mildred witnessed these final agonies, the Weimardammerung of the republic. And, like many of their generation, they turned their eyes eastward toward the Soviet Union, then in the midst of a revolutionary economic experiment called the Five-Year-Plan. The Harnacks, like many others, believed that capitalism was bankrupt and looked with hope and interest to what they believed was an egalitarian system that promised jobs and dignity to all.*

Little by little, the couple evolved from being simply curious about Marxism to committed Communists just as they changed from opposing Nazi policies to actively resisting them.

The next year, when the Nazis increased their membership in the German Reichstag from a dozen to 107, Mildred grew alarmed. In a letter to her mother, she noted that many Germans—the Nazis got six and a half million votes in 1930—were so desperate that they believed Hitler's promise to build a new Germany and decided a more absolute government was once again needed.

"The group calls itself the National Socialists although it has nothing to do with socialism and the name itself is a lie. It thinks itself highly moral and like the Ku Klux Klan makes a campaign of hatred against the Jews," Mildred wrote to her mother.

As she taught English literature and language classes at the University of Berlin and gave public lectures on American literature, she noticed her poor and hungry students were ripe for recruiting by the Nazis and Communists. Mildred and Arvid traveled separately to the Soviet Union

in 1932, deepening their interest and faith in Communism. However, they didn't notice the failures of Marxist social planning that were killing by starvation six thousand Soviets each day—a famine that would ultimately take six million lives.

The following January, Mildred mailed a postcard from Germany with these words: "There's so much to work for in the world nowadays. Never have been more glorious prospects…I'm thirty years old and a free woman—I have the work I want, there are no insurmountable obstacles to advancing in it…life is good." The card was dated January 29, 1933, the day before Hitler became Germany's chancellor.

As president of the American Women's Club in Berlin, Mildred met Martha Dodd, the twenty-four-year-old daughter of U.S. ambassador William E. Dodd, when the ambassador's family arrived in Germany in July 1933. The two became fast friends and worked together on a short-lived newspaper column. Martha Dodd, as recounted in Erik Larson's book *In the Garden of Beasts: Love, Terror, and an American Family in Hitler's Berlin*, was a complex and complicated woman. By the time she arrived in Berlin, she had written book reviews for the *Chicago Tribune*; was probably the lover of her mentor, Carl Sandburg; carried a picture of her friend Thornton Wilder in a locket around her neck; and deserted her first husband. Martha Dodd had affairs with a Gestapo chief, a senior Luftwaffe officer, a grandson of the last German kaiser and a French diplomat before falling in love with a Soviet intelligence officer who recruited her to spy for the USSR. She provided the Soviets with secret embassy information, as well as details of her father's reports to the State Department.

Martha Dodd and Mildred Harnack, who was six years older, spent much time together, traveled throughout Germany and found in each other confidantes and kindred spirits who shared a love of literature and writing. Martha Dodd frequently visited the Harnacks' apartment and enjoyed receiving Mildred's postcards when the couple traveled.

"I was drawn to her immediately. I knew intimately no other woman in Germany who possessed such sincerity and singleness of purpose," Martha Dodd wrote in an unpublished memoir.

Arvid Harnack became a lawyer for Lufthansa Airlines after the Nazis came to power and then got a job at the Ministry of Economics. His job as an economist and lawyer proved to be the perfect spot for a man who would later pass German economic information and secrets to the Soviets and Americans. When the Nazis changed civil service laws in early 1937, allowing them to fire tenured employees whose loyalty was in question, Arvid Harnack

was among a rush of civil servants who joined the Nazi Party, carrying membership card 4153569. By then, Arvid had already been passing secrets to the Soviets for almost two years. Arvid's KGB file, released decades later, revealed that he funneled information about Germany's economy, currency, foreign investments and debts, as well as documents detailing the country's secret trade agreements with the Baltic states, Persia and Poland, among other countries. For his part, Arvid, whose Soviet code name was Balt, never considered himself a spy or Soviet agent, merely a source of information. For years, he was never suspected as a traitor because, as an expert on the Soviet and American economies, Arvid had a plausible reason for meeting with Russian and American officials. Martha Dodd's assessment of Mildred and Arvid is included in the KGB files. She told Moscow that the Harnacks were highly trained, disciplined and entirely trustful.

The KGB file on Mildred noted she was "bold, tall, blue eyes, large figure, typically German looking [although] a lower-middle-class American, intelligent, sensitive, loyal, very much the German Frau, an intensely Nordic type and very useful."

The son of American diplomat Donald Heath was tutored by Mildred in English and American literature and fondly remembered her decades later in an interview with Brysac. Mildred wrote a reading list for Donald Heath Jr. that included *Gulliver's Travels* and *Beowulf*. He was thirteen when he last saw her in 1941.

"She was like Julie Christie in *Dr. Zhivago*, really very interesting. I was very attracted to her. She was very Germanic and wore out-of-date clothes. People would look at her. You noticed her across a crowded room," recalled Donald Heath Jr.

Because she could trace her ancestry back to a man who fought for Rhode Island during the Revolutionary War, Mildred became secretary of the Berlin chapter of the Daughters of the American Revolution in 1936, three years before the group barred Marian Anderson from singing in Constitution Hall because she was black. Mildred's membership enabled her to prove to the Nazis that she was 100 percent Aryan.

Mildred found work translating English-language books into German, including Irving Stone's biography of Vincent Van Gogh, *Lust for Life*, and Walter D. Edmonds's novel *Drums Along the Mohawk*. In time for the 1932 Los Angeles Olympics, she translated a book on European sports by Carl Diem, chief organizer of the Berlin Summer Olympics, who is credited with instituting the torch relay. Not everything she translated made it into print, though. Her translations of George Santayana's *The Last Puritan* and Stone's

biography of Jack London, *Sailor on Horseback*, were never published, evidently because they didn't pass muster with the Ministry of Propaganda. She was a freelance "reader" for German publishers, recommending American and British books suitable for translation. She lectured to German audiences on American literature and typed Ambassador Dodd's book on the American South. Her essays published in Berlin newspapers and magazines introduced to German readers young American writers like Thomas Wolfe and William Faulkner.

It's a sad irony that Mildred was translating the words of American authors for German readers during the height of the Nazi book burnings when Germany banned the works of John Dos Passos, Jack London, Upton Sinclair and Ernest Hemingway, among many other authors. The Nazis regulated all literary activities through the Reichskulturkammer, headed by Joseph Goebbels, which required membership for all German writers, publishers and librarians. Writing anything negative about the Nazi Party, or anything even construed as being negative, could end careers. German author Walter Mehring, whose own books were burned by the Nazis, compared Berlin to a film spooling in reverse with the literati who flocked to Berlin in the 1920s fleeing by the mid-1930s.

"As more and more German writers emigrated, were silenced, or were arrested, ironically, opportunities were created for the translation and publication of suitable works for foreign authors," wrote Brysac.

Mildred read Wolfe's *Look Homeward Angel* in 1933 and gave lectures on the American author at the American Women's Club in Berlin and to a group of German scholars and writers. She also wrote an essay about Wilder, Wolfe and Faulkner for a German newspaper, the *Berliner Tageblatt*. Mildred and Wolfe met when he came to Berlin in 1935 and became friends. He returned the next year to attend the Olympics, sitting in the American ambassador's box with Martha Dodd, with whom he was having an affair. After seeing a Jew arrested on a train in Germany, Wolfe wrote a scathing essay about the Nazis for *New Republic* magazine, which led to the banning of his books in Germany.

While publicly Mildred appeared to be simply an American expat working as a translator, teacher, scholar and lecturer, privately she was putting her skills to a different use. She and her friend Greta Kuckhoff translated speeches by Franklin Roosevelt and other world leaders, which were printed in leaflets, along with news and commentary in the foreign press about Nazi policies and labor movements. The leaflets were a way to bypass the official Nazi press, which printed no dissenting opinions. The

Nazis also controlled printing presses, paper and ink, making it difficult to covertly publish anything. But as a translator, Mildred could get rationed ink and paper, which was then used to print resistance pamphlets and publications. With her ties to the American embassy, Mildred interceded behind the scenes to help people escape Germany and obtain difficult-to-get visas. Holding both American and German passports, she performed covert operations on business trips and vacations to Norway, Denmark, France and England without raising suspicions in Germany because of her job as a literary scout for German publishers.

By then, her letters home to friends and family no longer expressed her political views because Mildred was wary of her mail being intercepted. On her last trip home during the 1937 lecture tour, people who knew the Mildred from Wisconsin noticed the change in the Mildred from Germany. The carefree, upbeat Mildred had turned into a remote, self-conscious woman, someone who had withstood years of scrutiny by Nazi neighbors and colleagues, who had become adept at hiding her feelings and opinions. The change led some to believe that Mildred had become a Nazi. Adding to the stress and strain of her visit were the members of the pro-Nazi German-American Volksbund who attended her lectures. Mildred told a nephew that she suspected she was being followed while she was in Wisconsin.

Meanwhile, in the Soviet Union, the first of Stalin's "show trials" of suspected enemies of the state began to cull the ranks of the Russian military, bureaucracy, diplomatic corps and intelligentsia. An estimated five million people were arrested and one million executed for real or imagined treason, among them five of the eight Soviet intelligence officers from Berlin, including men who were Arvid's contacts. The upheaval in the Soviet intelligence network meant Arvid had no contact with the USSR from June 1938 through August 1940. But that didn't mean Arvid stopped passing German secrets to other countries. Through Mildred's friends at the American embassy—which included George Messersmith, the Berlin consul general who warned broadcast journalist H.V. Kaltenborn in 1933 of Nazi aggression—Arvid began to convey vital information about Germany's economy to the United States. He was in a great position to do so; at the Economics Ministry, he worked in the department that handled foreign exchange and trade policy. In the summer of 1939, Arvid traveled to Washington, D.C., to handle German industrial property in the United States and to secure supplies of copper and aluminum. He warned U.S. Treasury officials that Germany would soon be at war and revealed German assets hidden in America that could be seized.

Mildred tried to leave Germany as early as 1936, writing to contacts at the University of Wisconsin inquiring about jobs and teaching positions but was told nothing was open due to high unemployment from the Depression and budget cuts on campus. Weeks after Germany invaded Poland, Mildred, who by then had finished her doctoral work and earned a PhD, unsuccessfully applied for Rockefeller and Guggenheim fellowships. While Mildred undoubtedly understood she could leave at any time and return to the safety of America, emotionally she was tied to Germany. She loved her husband, she loved the language of Goethe and she was committed to the cause of bringing down the Nazi regime.

"She would go with Arvid or she would not go at all, and Arvid would not leave," Brysac wrote. "As head of the Harnack family, he had his mother and siblings to consider. More importantly, he told his mother, 'We have to stay in this country: here is where our biggest enemies are. If we go, who will remain?'"

The Soviets resumed their relationship with Arvid in September 1940, when an agent in the Russian embassy showed up unannounced at the Harnacks' Berlin apartment. Arvid reluctantly agreed to help; his codename was changed to Corsican. Unlike other spies, Arvid was not a paid espionage agent, nor was his motivation to help the Soviet Union; rather, he saw his actions as a means to bring down the people steering his country over the abyss.

Just as friends and colleagues had been drawn to the Harnacks in Madison, they flocked to the couple's apartments—they moved often—in Germany, in a way creating a salon of anti-fascist intellectuals. Their circle included some of Mildred's former and current students, Martha Dodd, Adam and Greta Kuckhoff and Harro Schulze-Boysen, an officer in the Luftwaffe, and his wife, Libertas, who worked as a press agent for MGM studios in Berlin. Dozens were recruited into the Red Orchestra (*Rote Kapelle* in German), a nickname for resistance groups in Germany invented by Nazi counter-espionage leaders. The Red Orchestra was not only the Harnack and Schulze-Boysen group but also Soviet spy rings operating throughout Europe. Radio operators were called pianists, their transmitters were pianos and resistance leaders were conductors.

The Harnack and Schulze-Boysen group transmitted enciphered messages via radio transmitters and passed secrets to Soviet handlers they met surreptitiously in Berlin. Their fatal flaw was not of their doing. Instead, the Red Orchestra was brought down by Russian ineptness. In August 1941, the Soviets committed a terrible blunder, sending a coded message to their agent in Brussels, asking him to get in touch with the Red Orchestra. But instead of using only code names,

the message included the names of Adam Kuckhoff and Libertas Schulze-Boysen, their Berlin addresses and phone numbers and instructions to tell them that the Soviet agent was a friend of Arvid and Harro. The agent in Brussels was equally sloppy transmitting information from the Harnack and Schulze-Boysen group for long periods of time via his radio transmitter, which allowed Nazi agents to pinpoint his signal and arrest him.

It took the Nazis several months to crack the Soviet codes, but by the summer of 1942, they were monitoring phone calls and visitors to the Kuckhoff and Schulze-Boysen homes, unscrambling radio traffic and keeping dozens of people under surveillance. In late August, they moved in to make arrests. Mildred and Arvid were on vacation at a seaside resort in East Prussia when Gestapo agents took them into custody on September 6, 1942. They and more than one hundred others were taken to Gestapo headquarters on Prinz-Albrecht-Strasse 8 in Berlin, where many were tortured, though there is no official record to confirm whether Mildred was tortured, nor have any records of her interrogation been discovered. But she and Arvid were jailed under brutal conditions in cramped, damp cells. They were not allowed to communicate with others and were granted only a few minutes of fresh air each day.

Mildred Harnack photographed in Berlin during Christmas 1941. She was arrested in a roundup of anti-Nazi resisters the following September, and a few days before Christmas 1942, her beloved husband, Arvid, was hanged by the Nazis. She was executed less than two months later. *Courtesy of the German Resistance Memorial Center.*

Their trials were a fait accompli. No jury. No defense witnesses. No consultations with defense attorneys. In fact, Mildred was removed from the courtroom during the questioning of prosecution witnesses, mainly Gestapo agents. The verdicts of the panel of five judges were announced December 19: death for Arvid, the Schulze-Boysens and Adam Kuckhoff, along with many others. But Mildred appeared to be spared, her defense attorney's

assertion that she was simply being a good German wife, following her husband's orders, resonating with the judges. Arvid smiled when he heard Mildred's verdict.

In what was to be his last letter to Mildred, Arvid wrote movingly to the love of his life, recounting their happy times in Madison, getting engaged at Picnic Point and their first serious conversation during lunch at a State Street restaurant. He said he thought of her and his family every day at 8:00 a.m. and 6:00 p.m. and asked her to do the same:

> *My dearest love, If I have had the strength over these past months to remain inwardly calm and composed, and if I look ahead calmly and with composure to what lies ahead, this is because I feel part of all that is good and beautiful in the world, and because I share the feeling of which the poet Whitman sings toward the whole earth. Insofar as human beings are concerned, those close to me, especially you, were the incarnation of this.*

He finishes his letter:

> *You are in my heart. And you must always stay there. My greatest wish is for you to be happy when you think of me. I am when I think of you. Many, many kisses! I am holding you close, Your A.*

On December 22, 1942, a short rope was tied around Arvid's neck, and he was hanged from a hook, slowly strangling. That same night, Libertas Schulze-Boysen and her husband were executed by guillotine in the room where Arvid had died. Mildred didn't learn of Arvid's death until weeks later. By then, she, too, had been sentenced to die, also by guillotine, which the Germans used mostly on female prisoners because it was considered more humane. Like all executed prisoners at Plötzensee Prison, their grieving families were sent bills: one and a half Reichsmarks (sixty cents) for each day they had been detained, plus three hundred Reichsmarks ($120) for the executioner.

Mildred spent her last days at Charlottenberg Prison in Berlin, kept mostly away from the rest of the prisoners, who recalled seeing her stumbling with a fixed stare in the prison yard, wearing a gray hooded coat and a special armband with "T.K." embroidered on it—for *todeskandidatin*, or death candidate. On a rainy windy night, a van pulled into the prison yard. Mildred was placed in the back and driven to the guillotine at Plötzensee Prison. In the few hours that she waited to walk to her death, Mildred

traced Whitman's poem of Lincoln; exchanged her clothes for a sleeveless, open-necked garment; and gave to a prison guard a book written by one of her University of Wisconsin professors, inscribing it: "To Miss Klaing in memory of Feb. 16, 1943 in the room where you can see this beautiful tree through the window."

Mildred's last words, spoken to a chaplain, were: "And I have loved Germany so much."

The guillotine was dismantled when the war ended, its whereabouts unknown. The execution chamber still stands, along with the beam and hooks where Arvid and other members of the Red Orchestra were hanged, and is now a memorial. Estimates of the number of civilians executed following trials in Nazi courts range from twelve thousand to sixteen thousand between 1933 and 1945. At Plötzensee, three thousand people were executed.

The bodies of Mildred, Arvid and other Red Orchestra members were taken to the University of Berlin's Institute of Anatomy for dissection, organized by Dr. Hermann Stieve, whose main research focused on the effects of stress on women's reproductive systems. He used the bodies of thousands executed at Plötzensee and other prisons for his research, publishing 230 papers, which included details of the women's medical histories before they died. He kept records of some of the bodies; a typed list of names was found decades later in German government archives, according to a *Slate* article written by Emily Bazelon. Libertas Schulze-Boysen was No. 37 on Stieve's list. Mildred was No. 87.

Only one set of remains of executed Red Orchestra members were recovered: Mildred's.

Mildred received a proper burial only by a fluke; one of Arvid's nieces happened to be a medical student under Stieve. One day, the doctor called the niece into his lab and told her he had Mildred's remains, which the niece carried home in a shopping bag, according to Joel Waldinger, producer of a 2011 Wisconsin Public Television documentary on Mildred. She's buried in a cemetery in Berlin under a granite tombstone that says simply, "Arvid Harnack, Ph.D., Mildred Harnack, Ph.D."

In recent years, Mildred and the Red Orchestra have been recognized for their heroism, for their bold attempts to end Hitler's reign. Schools have been named after Mildred, plaques and monuments dedicated to the Red Orchestra and a stamp featuring the Harnacks was issued in East Germany in 1964.

And in Wisconsin schools, September 16 is Mildred Harnack Day. It's her birthday.

8
THE ASSOCIATED PRESS'S MAN IN BERLIN

If Louis Lochner ticked off Joseph Goebbels, he was doing something right. As the Associated Press Berlin bureau chief, Lochner had a front row seat to history. He covered the alarming rise of the Nazis and knew long before many had heard of Adolf Hitler that Germany was likely going to war. He was so well sourced as a newsman that he knew exactly when Germany would invade Poland and the exact date and minute when both Crete would be attacked and the Russian offensive would start.

Lochner was among a rare handful of journalists who were accredited to cover both the German army in battle—before America's entry into World War II—as well as U.S. forces. His coverage won the 1939 Pulitzer Prize, and two years later, in the days after the attack on Pearl Harbor when Germany declared war on America, Lochner was arrested by the Germans and interned for five months.

He translated and edited Goebbels's diary found in the courtyard of the Reich Ministry of Propaganda after Soviet troops occupying Berlin in 1945 rifled through German archives. The pages had narrowly escaped destruction; many were singed by fire and smelled of smoke. The unburned papers had been bundled by a junk dealer, who salvaged the binders to sell and tossed away more than seven thousand sheets of loose paper. But someone noticed the diaries had been typed on fine watermarked paper, a rarity in wartime Germany and available only to important government officials. Because of the paper quality, and not for the words written on them, the papers passed through several hands until an American who had

Associated Press Berlin bureau chief Louis Lochner (right) interviews Nazi minister of propaganda Joseph Goebbels. When Goebbels's diary was found following his suicide at the end of World War II, Lochner translated and edited it for publication. Among the diary's entries was one of Goebbels complaining about Lochner's attacks on the German propaganda machine. *Courtesy of the Wisconsin Historical Society (WHS-118602).*

served in the U.S. embassy in Berlin at the end of World War I noticed them. Eventually, Lochner was called on to examine the papers, and because he knew Goebbels, Lochner was in a position to declare them authentic.

Fluent in German and with two decades in Germany as a foreign correspondent, Lochner was the perfect person for the job. As he set about the herculean task, he came across Goebbels's May 19, 1942 entry. Lochner saw his own name on the page of the diary that the Reich's propaganda minister had kept locked in his safe.

"As regards the American journalists, the representative of the United Press [actually it was the Associated Press] Lochner is behaving in an especially contemptible way. His attacks are directed above all against German propaganda and he aims at me personally. I have never thought much of Lochner. We made too much fuss about him. We can now see what happens in time of crisis," Goebbels wrote.

Lochner grew up in a German-speaking household in Milwaukee—both his parents were German immigrants. He was born in Springfield, Illinois,

but moved to Milwaukee as an infant when his father found a job as a Lutheran pastor in the city where he had previously spent twenty-six years working as a minister. His mother came from a Silesian noble family whose ancestors included Count Christian von Haugwitz, the foreign minister known for negotiating the Treaty of Schönbrunn in 1805 with Napoleon Bonaparte on terms so unfavorable to Prussia that he was forced to resign. Lochner's mother, Maria, immigrated to America and became Friedrich Lochner's third wife. Louis Lochner—he was baptized Ludwig—was born when his mother was forty-one and his father sixty-four years old.

In his 1956 memoir, *Always the Unexpected*, his early memories included riding the new electric trolley in Milwaukee and, in 1893, visiting the Chicago World's Fair, where his parents bought him a ticket for the new Ferris wheel. Lochner's mother died when he was seven, and his half sister, Molly, and her husband, who taught at a Lutheran parochial school in Milwaukee, raised him and his two brothers.

Lochner grew up in the "German Athens of America"—a compliment to Milwaukee's culture and the heritage of the German immigrants and their descendants who settled mostly on the west side. It was also known as the city where English was taught as a second language and stores hung "English Spoken Here" signs in windows. Lochner, H.V. Kaltenborn and Mildred Harnack Fish were fluent in German, which helped further the careers that ultimately took them to Germany, where each, in turn, was caught up in World War II.

Lochner attended West Division High School and studied piano at the Wisconsin Conservatory of Music in Milwaukee, where he also sang in the chorus. At his 1905 graduation ceremony at the conservatory, Lochner performed Beethoven's Concerto No. 2, and five years later, he asked the girl who sat next to him in the chorus to marry him. He and Emmy Hoyer were engaged on New Year's Day 1910.

Lochner studied journalism at the University of Wisconsin–Madison and spent his summer vacation in 1908 working as a reporter at the *Milwaukee Free Press*. At the time Lochner was covering crime, politics and features for the *Free Press*, Milwaukeeans could get their news from more than a dozen newspapers, including publications in German, Polish and Bohemian. He recalled meeting Hans Hinrichs, a reporter for the *Milwaukee Germania*, at a tavern frequented by journalists and noticing that many of the English-language newspaper reporters disdained Milwaukee's foreign-language press. He struck up a friendship with Hinrichs and remained friends with him off and on for decades, by chance meeting again in March 1936, when

they both traveled on the maiden flight of the ill-fated dirigible *Hindenburg*. By then, Lochner had been living and working in Germany for years.

Before he moved to Germany and before he became a noted journalist, Lochner was a pacifist active in peace groups. During college, he attended an international meeting of students in Holland in 1909 and was influenced by a speech given by William T. Stead, editor of the *London Review of Reviews*. Stead told the students that modern wars had become so costly and destructive that countries would never risk "unleashing the terrifying instruments of death which technology has developed," Lochner wrote in his memoir.

Stead's words about world peace resonated with Lochner, who had no idea he would one day chronicle a war that did, in fact, unleash instruments of death, killing millions of people. Stead didn't live to see the wars he thought would never happen. He died in the sinking of the *Titanic* three years after Lochner listened to him speak.

After graduating from the University of Wisconsin in 1909, Lochner edited the UW alumni magazine, became active in the American Peace Society and was secretary and public relations agent for Henry Ford's Peace Ship, an unsuccessful effort to encourage countries fighting World War I to convene a peace conference. After Lochner's wife died in the Spanish flu epidemic, he moved to Berlin in 1921 and wrote for a labor press service, freelanced stories to daily newspapers in the Midwest and trade union publications and worked as Maxim Gorki's literary agent, helping the famous Russian writer find a publisher for his books in Japan. He married a German woman, and in 1924, he was hired to work at the Berlin bureau of the Associated Press, becoming bureau chief in 1928 and continuing in that post until 1942, when he was interned by the Nazis and finally kicked out of the country, along with other American journalists.

Joining the AP in Berlin was a dream come true for Lochner. "It was Big League journalism whose gates I had crashed. I was now working for the world's largest news-gathering association, whose daily dissemination of information covered events in every corner of the globe and was read by millions of readers," he wrote in his memoir.

Lochner's dispatches of the biggest story of the 1930s indeed would be read by millions, though most would never know it since the AP did not usually give bylines to its writers. But it would be primarily Lochner's words and photos in newspapers throughout the world that chronicled the rise of Adolf Hitler. He interviewed Hitler for the first time in 1925, shortly after the führer's release from prison and the publication of *Mein Kampf*. Lochner

interviewed Hitler several times and traveled with the German chancellor on a visit to Italy in 1938 to meet with Mussolini.

By then, Lochner could see the daily terror that settled over Germany like a suffocating blanket. He witnessed Brown Shirts beating people in the street. He heard the anguished cries from Gestapo headquarters on Berlin's Prinz Albrechtstrasse, where members of the Red Orchestra were later imprisoned. He repeatedly requested to visit concentration camps, which the Nazi propaganda office rebuffed.

And he caught Nazi press officers in lies—like the case of Fritz Husemann, president of the German Mine Worker's Federation. In April 1935, Lochner learned from sources within the German Social Democratic Party, which had been outlawed by the Nazis, that the Gestapo had taken Husemann to a concentration camp, where it was feared he would be murdered. So Lochner called the Propaganda Ministry's officer in charge to ask about Husemann. The official said he didn't know the union president had been arrested but would call the Gestapo and get back to Lochner. After hanging up with the press officer, Lochner called the police department in the small town where Husemann had been arrested and was told the police didn't keep records on dead people. When Lochner asked how he could find out when Husemann died, the police officer suggested he call the crematorium, which confirmed that his body had been delivered and cremated the day before.

When Lochner called the propaganda official back and asked if there was any news on Husemann, the official said he was hale and hearty in a concentration camp. "Then who was the Herr Husemann who was cremated yesterday at Krefeld?" asked Lochner, as he recounted in his 1942 book, *What About Germany?* After an embarrassed silence, the official said it couldn't be possible and he'd check with the Gestapo again. When he called Lochner back, he confirmed that Husemann was dead—killed while trying to "escape."

Whether by cultivating sources, old-fashioned shoe leather reporting or assiduously reading German newspapers and periodicals for tidbits of information that could lead to a bigger story, Lochner was adept at his job—a job that became more difficult when Hitler became chancellor in 1933 and many newspapers closed. Publications that remained open printed the same news, hand fed by Goebbels and the Propaganda Ministry. When the Nazis decreed that all German journalists needed government-issued permits to work, it choked off freedom of the press since anyone who wrote or said something not in line with the party would lose his or her accreditation and could no longer work as a journalist. Losing a job and livelihood at a time

when much of the world was in an economic depression meant there were few dissenting voices in Germany.

Foreign journalists working in Germany were not under quite as draconian restrictions, but they were kept under surveillance, their phones tapped, mail opened and conversations monitored. Some were expelled for stories that angered the Nazis. Even asking an embarrassing question at a press conference could get a journalist thrown out. Because Lochner represented the powerful American press, colleagues from small countries sometimes requested that he ask questions on their behalf, questions that would never lead to a story of any interest to American readers. But he would oblige and ask, "Has an agreement been reached on the importation of Danish bacon? Or did Economics Minister Funk make any deal concerning Turkish tobacco during his visit to Ankara?" he wrote in his memoir.

When British prime minister Neville Chamberlain triumphantly reported "peace in our time" following the 1938 Munich pact to appease Hitler and annex the Sudetenland area of Czechoslovakia to Germany, Lochner was flabbergasted. He couldn't understand the naïvety; he knew better than anyone that Hitler had lied, had not suddenly become a pacifist and would not stop until he dominated all of Europe.

One month later, Lochner wrote the following AP story:

> *Berlin, Nov. 10—The greatest wave of anti-Jewish violence since Adolf Hitler came to power in 1933 swept Nazi Germany today and Jews were threatened with new official measures against them.*
>
> *Millions of dollars worth of Jewish property was destroyed by angry crowds. Jewish stores were looted. Synagogues were burned, dynamited or damaged in a dozen cities.*
>
> *Sounds of breaking glass and shouts of looters died away only near midnight. Hundreds of Jews voluntarily spent the night in jails fearing worse violence as reports of burning and looting continued to come in from many cities.*

Those three paragraphs were the first many in the English-speaking world would learn of *Kristallnacht*, the night of broken glass.

Lochner was awarded the Pulitzer Prize for his coverage of Germany in 1939, and when he traveled to the United States to pick up the prestigious award, he found time to visit his hometown and stop at *The Milwaukee Journal*. Staffers in the newsroom asked Lochner where and when Hitler would strike next. Though Lochner's comments were off the record at the time of his

The Associated Press's Man in Berlin

Louis Lochner reporting from the front lines with Nazi troops. The longtime Associated Press Berlin bureau chief was one of the few American journalists embedded with both the German army—before America entered World War II—and Allied troops. *Courtesy of the Wisconsin Historical Society (WHS-118609).*

visit, *Journal* reporter Lawrence Eklund wrote a story published on October 24, 1942, recounting the AP newsman's prescient remarks.

Lochner told *Journal* reporters and editors in June 1939 that Hitler probably would not make a move until late August, and the crisis might involve border disturbances or trouble concerning a minority of Germans living in another country. He also told them not to underestimate Hitler.

After Germany invaded Poland in 1939, using the pretext of retaking land disputed between Poland and Germany, Lochner was among the foreign journalists who followed German troops as they swept through that country, followed by Denmark, Holland, Belgium, France, Yugoslavia, Greece and then through Finland into the USSR, cabling thousands of words from the front lines. He witnessed the French surrender in June 1940 in Compiegne in the same rail car where Germany had signed the armistice ending World War I. He was in Paris when Nazi troops marched down the Champs-Élysées. Foreign reporters were permitted to travel to the German front lines only when the Propaganda Ministry scheduled junkets for journalists to witness the final part of a successful maneuver. One time, though, Nazi propaganda officials miscalculated. Lochner and other journalists were invited to visit the Russian front via Finland, flying to Helsinki on July 31, 1941, because Hitler expected to conquer Leningrad by August 1. Leningrad never fell to the Nazis.

When he returned to Berlin from the Russian front in mid-August 1941, Lochner began to see more and more indications that to Hitler and German officials, it was only a matter of time before the United States joined the war. American correspondents were routinely excluded from press conferences, forced to listen to anti-American diatribes and found it increasingly difficult to do their jobs.

Once Germany declared war on America, Lochner knew his days as a journalist working freely in Berlin were numbered. But even the well-sourced Lochner didn't think that would happen until the spring of 1942 at the earliest. In early December 1941, the Wisconsin Conservatory of Music graduate attended a Mozart festival in Vienna, delightedly listening to operas, symphonies and chamber music recitals. He was back in Berlin dining with top Nazi officials when a telephone call from New York interrupted his dinner with an urgent message: "JAPS BOMBED PEARL HARBOR NEED FORN OFFICE REACTION." Lochner returned to his dinner companions, asked questions, scribbled some notes and phoned them in to his office. Two days later, the FBI arrested German newsmen in the United States.

"We didn't need to tell each other that, under the German system of reprisals, we were slated for similar treatment," Lochner wrote in *What About Germany?*

The next day, Lochner showed up for the daily press conference. A Nazi propaganda official told him and the other U.S. journalists to go home, which meant house arrest, until further notice. As the Americans walked out, their colleagues from other countries lined up to shake their hands and wish them luck. Lochner didn't go straight home, of course; this was news and he needed to file a story. So he wrote and dispatched his last news message from Germany, called the other AP journalists in Berlin and told them not to come into the office and thanked the bureau's German staff.

At his Berlin apartment, he packed a bag with clothing, toilet articles and cigarettes, which the nonsmoking Lochner knew might come in handy with guards and officials. At ten minutes to 1:00 a.m., the doorbell rang three times. Two plainclothes Gestapo agents with flashlights politely told Lochner to come with them.

"I seized the overnight bag from among the other pieces and said, 'Guess I'd better take this along.' Perplexed, the secret service agent exclaimed, 'But how did you know we were coming?'" Lochner wrote in *What About Germany?*

"Why do you think I'm a newsman?" replied Lochner.

Lochner and other American journalists, as well as U.S. citizens and officials who found themselves in Germany after the Pearl Harbor attack, were interned for almost five months at a hotel near Frankfurt. In a scrapbook in Lochner's papers at the Wisconsin Historical Society archives in Madison, the newsman affixed souvenirs of his internment at a chateau in Bad Nauheim, including black-and-white photos of prisoners performing daily calisthenics outdoors in the snow, color tourist ads of the hotel and a pamphlet listing classes taught by internees. Lochner and Milwaukeean George Kennan, a diplomat who would become one of America's preeminent Soviet experts, taught classes on American history and geography and German military history. By late May, the Germans released them in a prisoner swap.

When Lochner returned to the United States on June 1, 1942, an Associated Press colleague slapped him on the back and asked, "What about Germany?"—a question repeated frequently to him over the following weeks. He decided to write a book with the same title published later that year. In a couple hundred pages, he outlined succinctly and eloquently how Hitler managed to take over an entire country and twist Germans to his obscene ideas, and he explained why no one stopped Hitler before it was too late. He explained Hitler's hypnotic effect on crowds, his great skills as a

speaker and his astute political instincts. In the book's foreword, he eschewed his wire service objectivity and allowed his emotions to flow. "I want the reader to feel as burning an anger as I do at the perversion of civilization that Adolf Hitler is trying to foist on an unwilling world," Lochner wrote.

Lochner embarked on a lecture tour following the book's publication, which included a stop in Milwaukee, where he spoke at the Auditorium and visited with fellow Milwaukee Press Club members. The October 24, 1942 *Journal* article included a photo of Lochner standing next to Hitler that he had used to curry favor with German border guards pawing through his luggage. In response to accusations by some American newspaper readers that his coverage of the German war machine before Pearl Harbor sounded too enthusiastic, Lochner said that his graphic descriptions of invasions and the fall of Paris and Dunkirk were warnings to the American public of Germany's military strength.

"We of the Associated Press had instructions to stay in the country," Lochner said in a speech at the Milwaukee Press Club shortly after he was released from German custody.

> *A reporter for an individual paper could go over the borderline and be kicked out because his paper could always fall back on a service like that of the Associated Press. The AP had to stay there, and it's a matter of gratification to us of the AP to come back to this country and find that what we have been writing since our release from internment is merely an embellishment and filling in of the basic truths we wrote from Germany.*

After the publication of *What About Germany?* and a lecture tour, Lochner spent seventeen months as a commentator for NBC radio on the West Coast. In October 1944, as Allied troops edged closer to Berlin and just a few months before the Battle of the Bulge, Lochner was recalled to active service with the AP. He returned to Europe, this time reporting on American troops as they fought against the German army he had followed into battle at the war's start.

"I had gnashed my teeth many a time in impotent rage when I saw how Hitler was overrunning Europe. Now I was retracing my steps this time with an army determined to restore freedom to Europe. It made all the difference in the world to me," said Lochner.

After the once powerful German army was defeated and Hitler committed suicide in an underground bunker in Berlin, Lochner stayed to cover the Nuremberg Trials of Nazi war criminals. In a way, it was

The Associated Press's Man in Berlin

Louis Lochner earned a Pulitzer Prize in 1939 for his coverage of the events leading up to World War II and his dispatches from battlefields in Europe. *Courtesy of the Wisconsin Historical Society (WHS-118604).*

full circle for the journalist who had a front row seat to Germany's rise from the ashes of World War I, the ascension of Hitler and the Nazi Party and the downfall and terrible destruction at the end of the Second World War.

Louis Lochner lived out his last years in Germany. He died there in 1975.

His son Robert Lochner, who moved to Berlin with his family when he was five and later helped his father cover the 1936 Berlin Olympics for the AP, was a member of the U.S. occupation forces in Germany after the war. He had a distinguished career—director of radio news in the U.S.-occupied zone of Germany, editor of a Frankfurt newspaper, head of information at the U.S. embassy in Saigon in the mid-'50s, leader of the Voice of America's European division, press and cultural attaché at the American embassy in Bern, Switzerland, and a correspondent in Berlin for *ABC News* in the 1970s and '80s.

Robert Lochner was also a translator for high-ranking American officials and dignitaries visiting Germany, including former president Herbert Hoover and Vice President Lyndon Johnson. He worked with John F. Kennedy, preparing the president for his historic visit to Germany

in June 1963, twenty-two months after the Soviets erected the wall separating East and West Berlin. It was Robert Lochner who coached Kennedy on the proper pronunciation of German phrases. Among them: "*Ich bin ein Berliner.*"

9

THE DEAN OF BROADCAST NEWS

Hans V. Kaltenborn didn't believe it. Reports of Nazi Brown Shirts beating up Americans in Germany for failing to give the Nazi salute surely were exaggerated. Born in Milwaukee and raised in a German-speaking home, the famous radio commentator and reporter decided to travel to his parents' homeland, a country he had visited on numerous reporting trips, to see for himself.

American consul General George S. Messersmith had seen the wounds of American visitors and expatriates caught up in the violent fervor in the weeks and months after Hitler came to power. Before Kaltenborn left the United States, he read some of Messersmith's dispatches, and after spending several days in Berlin, he told Messersmith that the consul general's reports were off base. But Kaltenborn soon learned what Messersmith knew: Germany had radically changed.

As Erik Larson recounted in his 2012 book, *In the Garden of Beasts: Love, Terror and American Family in Berlin*, Kaltenborn and his family were leaving Berlin on the morning of September 1, 1933, when they saw a group of storm troopers marching toward them.

Kaltenborn knew that foreigners were not obligated to give the Nazi salute, and he told his wife, daughter and son to turn their backs on the parade and look into a shop window. But several Nazis surrounded the family and demanded to know why they were not saluting. Kaltenborn replied in German that they were Americans. When a crowd began to threaten the Kaltenborns, he asked two nearby police officers for help, but

the police ignored him. As they walked to their hotel, Rolf Kaltenborn, sixteen, was grabbed from behind, punched in the face and knocked to the ground. Kaltenborn grabbed the attacker and pushed him toward the police officers, but as the crowd grew even more menacing, Kaltenborn must have realized his family was at more risk. After returning to his hotel, he contacted Messersmith.

The consul general later wrote, "It was ironical that this was just one of the things which Kaltenborn said could not happen. One of the things he specifically said I was incorrectly reporting on was that the police did not do anything to protect people against attacks."

Unlike Louis Lochner, who was stationed in Germany as the Berlin bureau chief for the Associated Press, Kaltenborn was based in the United States and traveled extensively around the world as a newspaper and radio correspondent. Occasionally parachuting into Germany on reporting trips, he didn't see the gradual buildup to the Nazi power grab. The attack on his teenage son opened Kaltenborn's eyes, though he never mentioned it on the radio and only briefly in his memoir, *Fifty Fabulous Years: 1900 to 1950*.

"In the summer of 1933 my son Rolf was struck by a Nazi storm trooper for failing to salute one of the endless passing parades of Nazi banners. When the German Propaganda Ministry heard of the incident they sent me a formal written apology in the hope that I would not feature my son's misadventure in a broadcast. I had, of course, no intention of exploiting a personal experience," Kaltenborn wrote.

Kaltenborn grew up speaking German more than English at home. His father, Baron Rudolph von Kaltenborn-Stachau, came from a long line of Hessian military men and immigrated to Wisconsin when the small, independent German state of Hesse was absorbed by Prussia. He returned to fight in the Franco-Prussian War and met his future wife on the ship sailing back to the United States. Kaltenborn's father worked as a teacher, bookkeeper and secretary in a wholesale drug business in Milwaukee and later bought a building supply company in the central Wisconsin community of Merrill. Kaltenborn's mother died when he was born. From kindergarten through fourth grade, he attended the German-English Academy in Milwaukee and spoke German with practically no American accent.

He enlisted in the Fourth Wisconsin Volunteer Infantry to fight in the Spanish-American War, though he never saw action and didn't leave the United States. He sent weekly reports of camp life to *The Milwaukee Journal*, the *Merrill Advocate* and the *Lincoln County Anzeiger*, a German-language daily printed in Merrill. Leaving Wisconsin to serve in the army apparently stirred

in Kaltenborn a fever for foreign travel. He never really returned home to Wisconsin. He found a job at the *Brooklyn Daily Eagle* in 1902, compiling stock tables during the day and covering night assignments, moved up to city hall reporter and then left the *Daily Eagle* for a few years to study at Harvard on a scholarship for working journalists similar to today's Nieman Fellowships. He earned money for expenses as a Harvard correspondent for the *New York Post* and *Brooklyn Daily Eagle*, as a German tutor and by translating scholars' theses from German into English.

At Harvard, he worked on the university's dramatic club with John Reed, best known for *Ten Days That Shook the World*, his firsthand account of the Bolshevik revolution in Russia. After Reed covered the Mexican revolution and the opening phase of World War I for *Colliers*, Kaltenborn noticed a profound change in his former classmate, who had become more mature and more radical. Reed died of typhus in Moscow in 1920; he's one of only two Americans buried in the wall of the Kremlin, which was considered a great honor.

After graduating from Harvard, Kaltenborn was hired by millionaire John Jacob Astor to prepare his son Vincent for Harvard, coach him for the entrance exam and look after him on a trip to Europe. A few years later, Kaltenborn was back in Brooklyn working at the *Daily Eagle* when an acquaintance from Merrill, a popcorn seller and Englishman named Dan Cochran, stayed with Kaltenborn in New York on his way to visit relatives in England. Kaltenborn made the arrangements for Cochran's round-trip steerage passage. The return ticket was on the *Titanic*.

Both John Jacob Astor and Cochran "were swallowed by the Atlantic," Kaltenborn wrote in his memoir. "It was a sad business for those of us whose lot it was to report the disaster and compile the names of the dead and missing. We reporters were often the first to notify those whose loved ones were lost."

In January 1914, Kaltenborn was sent to France to run the *Brooklyn Daily Eagle*'s Paris bureau, and in a visit to Germany in April, he was astonished at the extent and thoroughness of the country's war preparations. That summer, he returned home to Brooklyn, and when World War I broke out following the assassination in Sarajevo of Archduke Franz Ferdinand and his wife, Kaltenborn became the *Eagle*'s war editor, selecting and editing press reports from the front.

After World War I, Kaltenborn traveled extensively for the Brooklyn newspaper, meeting politicians and celebrities, interviewing the famous and the obscure ranging from Sigmund Freud to the man who embalmed

Vladimir Lenin's corpse. In 1922, he began a series of radio talks on current events in New York while still working at the Brooklyn newspaper. On a 1923 visit to Germany to write about reparations from World War I, he visited the Nazi headquarters in Munich and was "amazed at the power and organization which Hitler's private army had already achieved."

He quit the *Brooklyn Daily Eagle* in 1930, when he was asked to take a big pay cut, and signed a contract with the new Columbia Broadcasting System for regular weekly news commentaries and special events. In his clipped midwestern accent, Kaltenborn never read from a script but spoke off the cuff from notes he'd written.

Kaltenborn's fluency in German allowed him to give listeners the news from Germany much quicker than other journalists. Louis Lochner recalled in his 1956 memoir, *Always the Unexpected*, listening to Kaltenborn relay an in-depth and accurate summary of one of Hitler's speeches right after the führer finishing talking, something no other newscasters, who had to wait for translations, could do.

Lochner and Kaltenborn interviewed Hitler in his native language on several occasions and posed for a photo with him and Karl von Wiegand, a Hearst newspapers correspondent, following an interview on August 17, 1932, at Hitler's Bavarian retreat. Both Kaltenborn and Lochner later found value in the photo. Kaltenborn showed it to Republican forces fighting the Spanish Civil War to gain access to their fighters while Lochner often packed a copy of the photo on top of his shirts in his suitcase when crossing German borders on reporting assignments. Customs inspections always went quickly and smoothly when he did that.

In the interview shortly before Hitler became ruler of Germany, the American journalists worked out a plan.

"As a rule, Hitler monopolizes the conversation," Lochner wrote in *What About Germany?* "In fact, when H.V. Kaltenborn of the National Broadcasting System and I visited him six months before he became chancellor, we were able to obtain answers to the questions we had agreed on only by alternately interrupting his flow of words rather rudely."

Scoring a sit-down with Hitler was difficult. The Nazi leader frequently avoided contact with anyone who might disagree with him—like American journalists who couldn't be counted on to limit their questions to the party line. Finally, an interview was arranged through Kaltenborn's former Harvard classmate and friend Ernst "Putzi" Hanfstaengl, the Nazi foreign press chief. On his frequent visits to Germany, Kaltenborn often met with Hanfstaengl, who arranged for interviews with Nazi leaders in the early years of the movement.

The Dean of Broadcast News

Radio newsman H.V. Kaltenborn poses with Adolf Hitler following an interview on August 17, 1932, at Hitler's home in Bavaria several months before he became chancellor of Germany. The original photo showed Louis Lochner on the other side of Hitler. Both Lochner and Kaltenborn later found value in the photo; Kaltenborn used it to gain access to Fascist forces during the Spanish Civil War, and Lochner put a copy in his bag when he crossed the German border to smooth customs inspections. *Courtesy of the Wisconsin Historical Society (WHS-120731).*

World War II Milwaukee

H.V. Kaltenborn interviews troops during the Spanish Civil War. In an incredible coup, he managed to broadcast the war live from an abandoned farmhouse near Irun, Spain, using a phone link through Bordeaux, Paris and London and a short-wave transmission to New York. *Courtesy of the Wisconsin Historical Societ (WHS-120732).*

But Hitler had been elusive. Then, in the summer of 1932, Hanfstaengl sent Kaltenborn a telegram telling him Hitler would meet him the next day at Hitler's home in Berchtesgaden. Lochner called Kaltenborn to say he had gotten the same summons. When they arrived, they were disappointed to learn that von Wiegand was also getting an interview. Von Wiegand met with Hitler alone but left a short time later, complaining to Kaltenborn and Lochner that the Nazi leader was difficult to interview. Next up were Lochner and Kaltenborn.

Kaltenborn's first impression of Hitler was not favorable. As the American journalists stepped up to the chalet's open porch, an unsmiling Hitler greeted them with latent hostility, Kaltenborn recalled in a 1967 *Wisconsin Magazine of History* article. The contrast between Hitler's animosity and the lovely and relaxing surroundings was striking—the beautiful Bavarian mountains, the sound of Hitler's canaries and cockatoos chirping through an open window and Hitler's freshly cleaned shirts and slacks fluttering on clotheslines at the side of his cottage.

Kaltenborn later wrote that when they sat down, he asked the first question without giving Hitler or Lochner a chance to open the conversation: "In your attitude of antagonism towards the Jews, do you differentiate between German Jews and the Jews who have come into Germany from other countries?"

Kaltenborn knew many Germans often tried to justify anti-Semitism by saying it was directed primarily against Jews who arrived in Germany after World War I. But he also knew that the Nazis did not make that distinction, and he wanted to get Hitler on the record. Hitler stared at Kaltenborn with piercing eyes and launched into a tirade about America's Monroe Doctrine—that America excluded any would-be immigrants it didn't want to cross its borders, demanded they meet physical standards, examined their political opinions and insisted they bring with them a certain amount of money.

"We demand the same right," Hitler told Kaltenborn and Lochner. "We have no concern with the Jews of other lands. But we are concerned about any anti-German elements in our own country. And we demand the right to deal with them as we see fit."

During the interview Kaltenborn watched a large wolfhound run across the lawn and up the steps of the porch:

> *He approached his master expecting to be petted. But Hitler, irritated at the interruption, frowned at the dog and pointing with his finger under a nearby table, pronounced the single word "Platz!" which means "Take your place" or "Lie down."*
>
> *The dog, in accord with Nazi tradition, obeyed immediately, but I could see him watch his master out of the corner of his eye. As Hitler continued talking the dog got up slowly, so as not to be observed, and while Hitler was absorbed in oratory, slunk away. I could understand that a man with Hitler's temperament, background and experience might not care to make a friendly gesture towards an American correspondent, but it was surprising to see him observe the same stern aloofness towards his own dog.*

The American journalists asked questions about the German government, big business, Hitler's policies and whether he contemplated instituting a Fascist bloc from the Baltic to the Mediterranean. On the last question, Hitler said he didn't have a formal bloc in mind but that Europe was accustomed to being governed by one system that crossed frontiers. "Mussolini has said that Fascism was not an article of export. I can say the same of National Socialism. Yet people are coming to me from every country in Europe to ask

me for my recipe of government. They want my advice on how to launch movements in their own country," said Hitler.

It's easy to look back years later and say people should have known. They should have understood Hitler would try to take over most of the world, kill millions, single out Jews for mass extermination and reduce much of Europe to rubble. But for journalists like Kaltenborn and Lochner, Hitler initially seemed to be a mostly harmless nut. Kaltenborn wrote in his memoir that after the 1932 interview that he misjudged Hitler because he thought he was too much of a fanatic and too vehement in his beliefs to appeal to Germans. Kaltenborn underestimated Hitler's magnetic power and fanatical drive and overestimated the will of the German people to resist.

"Those of us who met him before 1933 could not imagine that such a person would ever be able to translate into action the plans he had sketched in *Mein Kampf*. He did not appear to have his own mental and physical processes under sufficient control to be able to harness them to the achievement of a specific goal," wrote Kaltenborn. "What we underestimated was the appeal of the irrational and the impact of cleverly manipulated and constantly hammered propaganda on the minds and emotions of the German people."

Months later, Hitler became Germany's chancellor, rapidly built up his country's military and armaments industry, changed laws to turn Jews into second-class citizens, opened concentration camps and began gobbling up land—first Austria and then the Sudetenland in Czechoslovakia—without firing a shot. During the twenty days in September 1938 that culminated in the Munich Agreement to appease Hitler, Kaltenborn made 102 radio broadcasts, from two minutes to two hours in length, juggling reports from foreign correspondents, analyzing and translating speeches and scanning news bulletins handed to him as he talked. Americans were listening on new hand-held radios and crowding around taxicabs to hear news of the Czech crisis. Kaltenborn napped on a cot at the radio station, refueling on coffee and sandwiches his wife brought from a nearby drugstore.

When the crisis was over, most Europeans wanted to believe that giving Hitler part of Czechoslovakia would mean peace. Kaltenborn didn't think so. In his last broadcast at the end of the Munich Crisis, he reminded listeners that Hitler always said after his conquests that there would be no more. But Kaltenborn cautioned that there would always be more, that Hitler would not stop unless he was stopped.

One week before German troops marched into Poland and World War II began, Kaltenborn flew from London to Germany to see the storm center of Europe. It was apparent to most that war was imminent, though when it

would start was a guessing game. Kaltenborn traveled to Germany after CBS correspondent William L. Shirer, who was stationed in Berlin, had made sure Nazi officials were OK with his visit, though he could not broadcast from Germany or see any officials. But Kaltenborn's visit was unexpectedly brief.

Shirer wrote in his personal journal that he became suspicious when passport officials continued to detain Kaltenborn after all other passengers on the flight were cleared. After a couple hours in the airport, the secret police told Kaltenborn he had to return to London on the next flight. "We have been nicely double crossed by the Nazis," wrote Shirer in *Berlin Diary: The Journal of a Foreign Correspondent, 1934–1941*.

The secret police told Kaltenborn he couldn't stay because he had insulted Hitler during a lecture in Oklahoma City, Oklahoma. Kaltenborn didn't argue. He had attacked Hitler in many broadcasts and speeches. When he tried to get on the next flight to London, though, it was full. Kaltenborn thought he might be able to stay but was dismayed to see the Nazis pull another passenger off the flight and give the American newsman the suddenly open seat. Just before he boarded the flight, Kaltenborn remembered he had brought some American pipe tobacco for Shirer. As he tried to hand the tobacco to Shirer, the Gestapo confiscated it. Though disappointed about his short visit to Germany, Kaltenborn—and Shirer—knew it could have ended much worse. Kaltenborn could have been jailed.

When he returned to America on August 30, 1939, reporters asked him if war was about to break out in Europe. Kaltenborn didn't think so. "How do I account for my wrong guess? After visiting England and seeing for myself how utterly unprepared the British were for war, I could not see how the British would dare at that point to challenge Hitler's military might if they could find some formula that would postpone the evil day," Kaltenborn wrote in his memoir.

Kaltenborn later admitted that he failed to consider the determination and courage of the British. After the United States entered the war—by then he was working for NBC—he traveled to the Pacific to report on the fighting, first stopping in Pearl Harbor almost two years after the surprise attack and was shocked at seeing the *Arizona* and other damaged ships in the fleet. Few Americans at that time, including journalists like Kaltenborn, knew the extent of the attack on America's Pacific Fleet in Hawaii. On the island of Bougainville, he was awakened at night by regular Japanese bombing raids. At Guadalcanal, he was excited to make the first network broadcast from the capital of the Solomon Islands, where bloody battles on land and sea had taken the lives of thousands. After getting clearance from the army censor of

his script describing in detail the scene on Guadalcanal and the work done by American military members, Kaltenborn opened his broadcast from Guadalcanal with a sergeant singing a few bars of a popular song.

Soon after he triumphantly finished the first-ever newscast from Guadalcanal, he learned that no one other than the people in the tent housing the radio transmitter actually heard his words. His broadcast had been cut off as soon as the soldier sang. The music hadn't been cleared for copyright purposes.

The next year, he traveled to visit troops in Belgium and Holland, and on his way back to the United States, he stopped for a few days in London, where he witnessed the first German V-2 rockets landing in England. He was dining with British newspaper publisher Lord Beaverbrook when he heard a tremendous explosion, shaking the windows and dishes on the table. With the "Keep Calm and Carry On" attitude of Londoners, all of the dinner guests continued their conversations as if nothing had happened, Kaltenborn recalled. The next morning, he drove to the block hit by the V-2 rockets, the first long-range guided ballistic missiles, and was impressed to see everything had already been cleaned around the crater that filled the entire city block—glass swept up, piles of rubble cleared away and three fatalities and twelve wounded carted away by ambulances. He did see one ambulance still on the scene, from the Society for the Prevention of Cruelty to Animals, and half a dozen workers digging to rescue a horse buried in the bombing.

After World War II, he continued to travel widely and covered the Berlin Airlift in 1948, flying into Berlin with his wife and ten tons of coal. In addition to portraying himself in *Mr. Smith Goes to Washington* announcing the filibuster of the character played by Jimmy Stewart, he also appeared as himself in *The Babe Ruth Story* and *The Day the Earth Stood Still* and as a panelist on the TV program *Who Said That?* He retired from full-time broadcasting in 1955, though he handled analysis of the Democratic and GOP conventions the next year for NBC television.

Kaltenborn died in 1965 and was buried at a Milwaukee cemetery located fittingly, for someone whose German heritage and language skills helped him go far in journalism, on North Teutonia Avenue.

10
THE WOMAN ON THE FRONT LINES

At first she looked at the faces of the injured and dying only through the viewfinder of her four- by five-inch Speed Graphic. Boats weighed down by stretchers had been traveling all day from the black sand beaches out to the hospital ship anchored off Iwo Jima.

As the stretcher-bearers brought more than five hundred critically injured marines to the USS *Samaritan*, the moans and cursing of the injured and revving of small boat engines delivering their loads surrounded Dickey Chapelle. Soon, she could smell plaster dust from fresh casts in the orthopedic ward and decomposing flesh in the ward handling abdominal wounds. Avoiding the slippery pools of blood on the deck, she tried to stay out of the way and focus on her job: taking photos for a magazine.

"The shapeless dirty bloody green bundles being lifted and carried before me were not *repeat not* humans as I was human," she wrote in her 1962 autobiography, *What's a Woman Doing Here?* "Some part of my mind warned me that if I thought of them as people, just once, I'd be unable to take any more pictures. Then the story of their anguish would never be told since there was no one else here to tell it."

But then she saw a corporal from Pennsylvania who was in such bad shape that a medical corpsman didn't bother to move him as he began transfusing whole blood a few yards from where the injured man had been lifted on board the hospital ship. Since his stretcher was the only one staying put for a few minutes, Chapelle knelt beside it to change the film in her camera. As she worked, she stole a look at the marine. Someone had scribbled "M" on

his forehead for the morphine he had been given. She reached up to move the "Urgent" tag tied to his top shirt button, which had fallen across his lips, so he could breathe easier. He tried to smile.

Chapelle said, "Soldier—how are you?"

Among the many things the Milwaukee native learned on her first day as a combat photographer, Chapelle discovered that marines are very sensitive about being called anything but a marine. So the critically wounded corporal enlightened her, carefully enunciating the word marine and slowly sounding out the syllables of the F-bomb he used to punctuate his message.

Point taken.

Chapelle was a quick study. Born Georgette Meyer in Milwaukee, she grew up in the suburb of Shorewood, earning a scholarship to MIT when she was just sixteen to study aeronautical design. The year before she left for college, she saw a documentary at the Oriental Theater of Admiral Richard "Dickey" Byrd's South Pole expedition and became infatuated with Byrd and flight. She adopted his nickname and began hanging out at Curtiss-Wright Field, now called Timmerman Airport, on Milwaukee's northwest side.

The Admiral Byrd documentary "hypnotized me. I came home in a daze and announced I was going to be an aerial explorer," she wrote in her autobiography. "Being a girl might slow me down a little, but there was no other reason not to follow in his footsteps. The first thing I'd do would be to learn to fly."

When she told her mother of her plans to get a pilot's license, her mother said absolutely not. Chapelle left for MIT after graduating from Shorewood High School in 1935 and supported herself as a German tutor, a language she had learned from her grandmother. But she flunked out after only two years because she spent so much time at airports watching planes take off and land. When she returned to Milwaukee, she got a job typing pilots' correspondence at Curtiss-Wright Field in return for flying lessons, though she never did earn a pilot's license, in part because of her nearsightedness. She didn't stay in Milwaukee for long, moving to Florida to live with her grandparents and working as an air show publicist. Chapelle was sent as a freelancer for the *New York Times* to cover an air show in Havana, where she watched the chief of the Cuban air force try to perform a stunt in front of the crowd. When his plane slammed into the ground, she ran to the wreckage, shouting that she was a member of the press, and noticed the pilot's "gleaming propeller blade had become his executioner's sword and its silver gleamed no longer."

The Woman on the Front Lines

Dickey Chapelle poses in a flight suit and parachute as a member of Women Flyers of America, which was formed in 1940 to teach women to fly and ferry American bombers to Britain. Because of poor eyesight, Chapelle did not become a pilot, though a decade later she learned to jump out of airplanes with paratroopers. *Courtesy of the Wisconsin Historical Society, photo by the* Milwaukee Journal Sentinel *(WHS-11541)*.

The story she filed of the Havana air show crash led to a job in New York in 1939 in the publicity offices of TWA, writing press releases sent to the city's thirteen daily newspapers and wire services. She met Tony Chapelle, a

pilot and photography instructor who handled the airline's publicity photos. She was a student in his weekly photography class. They fell in love.

Under Tony Chapelle's guidance, she learned to use the Speed Graphic, so bulky that it forced users to plan the picture in their minds and then move into the vantage point before pulling the square viewfinder up to their eyes. He taught her to always keep her equipment loaded with a fresh supply of film, to judge light intensity until her fingers automatically adjusted aperture and shutter speed each time a cloud passed in front of the sun. She practiced estimating the distance of her subjects to focus her camera and the speed of passing objects to gauge the correct shutter speed.

"I was awestruck by Tony in this drill instructor role. Fearful of his Homeric wrath, I learned my lessons bone-deep as quickly as I could. And I don't think I've ever forgotten any of them," she wrote.

Tony Chapelle pointed out the contrast between reporters and photographers, telling her, "You have to be able to write, too, so you can do captions. But the picture is your reason for being. It doesn't matter what you've seen with your eyes. If you can't prove it happened with a picture, it didn't happen."

They got married in Shorewood in 1940, and while honeymooning in Canada, they filed a story and photos for the Scripps-Howard newspaper chain about American fliers volunteering to fight in the Royal Canadian Air Force. She quit her press job at TWA and began to freelance, selling her first story to *Look* magazine, a feature about a woman at a New Jersey aircraft plant who sewed fabric on the wings of British planes headed overseas. They were driving in Upstate New York on December 7, 1941, when they heard the news bulletin on their radio. Tony Chapelle, a military photographer during World War I, rejoined the navy and was sent to Panama to train navy combat photographers. She followed him there on assignment for *Look*. For much of the war, though, the couple was in New York, where Dickey wrote several books on aviation. Just before Christmas 1944, the military sent Tony Chapelle to China, and Dickey managed to convince *Woman's Day* to send her to the Pacific to cover the war from a woman's perspective.

Flying to Hawaii in February 1945, she heard the name of the desolate island for the first time when the plane's co-pilot told passengers the invasion of Iwo Jima was going badly. In the pressroom at navy headquarters in Pearl Harbor, she was riveted by reports coming through the teletype machine, reports of entire marine units getting decimated. She flew to Guam with a group of army nurses and watched more teletype dispatches, which were rewritten by press association men who had stayed behind to relay news

from their colleagues on the front lines. The reports were filed from the USS *Eldorado*, the communications ship of the assault fleet, including the following dispatch, as Chapelle recounted in her autobiography:

> ABOARD THE COMMAND SHIP OF THE ASSAULT FORCE ANCHORED OFF IWO JIMA—AN UNCONFIRMED RUMOR IS SWEEPING THE SHIP THAT THE FLAG HAS BEEN SIGHTED ON THE TOP OF THE HIGHEST POINT OF THE SAVAGELY CONTESTED SOIL OF...
>
> *Now the men were scornful. They said the teleprinter aboard the* Eldorado *must be making a bad joke. They agreed not to relay such an improbable rumor back to their offices in the States. The teletype began to click again:*
>
> IT HAS BEEN OFFICIALLY CONFIRMED THAT THE FLAG OF THE UNITED STATES NOW FLIES FROM MOUNT SURIBACHI HIGHEST POINT OF THIS VOLCANIC ISLAND.
>
> *The words galvanized the pressroom. Three of the men cheered. Now that I was sure it was all right for a correspondent to show emotion, I wiped my eyes with my knuckles.*

When a naval aide asked her where she wanted to go, she immediately said, "As far forward as you'll let me." She got orders to board the *Samaritan*, which left Guam and headed to Iwo Jima, arriving on D-Day Plus 6. It took only two days for the hospital ship to fill to capacity with wounded troops and then sail to Saipan to deliver men to hospitals. Chapelle recorded everything with her cameras and then returned to Guam, where she learned that a few correspondents were hitching rides to Iwo Jima on planes shuttling the wounded. She flew back to Iwo Jima, arriving on D-Day Plus 11, visiting field hospitals, shooting photos and interviewing marines. When two marine lieutenants asked her where she wanted to go, she again said, "As far forward as you'll let me."

The marines obliged, driving her to the front lines. But when she got there, she was disappointed. She could see a few marines off in the distance digging a hole and disappearing into it but no one else. She heard scattered rifle shots off in the distance. Chapelle knew photos of a marine lieutenant standing next to a truck parked on sand would never excite her editor. So she

With her Speed Graphic camera, Dickey Chapelle snaps a self-portrait in a mirror wearing the armband of a combat photographer issued by the U.S. military during World War II, when she worked for *Look* magazine and other publications. *Courtesy of the Wisconsin Historical Society (WHS-64787).*

climbed alone up to the top of a ridge and shot pictures showing a part of the island honeycombed with waffle-like ridges. She planted her feet in the sand to steady herself while snapping the shutter. In the heat, she could hear only her own breathing, the buzzing of insects and the crunch of her boots. When she returned to the marine lieutenant, he told her the first rule in a combat zone

is to never stand up on a ridge, especially not for ten minutes—plenty of time for artillery and snipers on both sides to take aim.

Back on Guam, she told another correspondent about her visit to Iwo Jima. And she learned the buzzing of wasps she had heard on the ridge were not actually wasps—because there were no insects on Iwo Jima. But there were plenty of snipers.

In April 1945, Chapelle traveled on a hospital ship with the invasion fleet to Okinawa to illustrate how blood donations from America were being used to save the lives of troops fighting in the Pacific. She convinced a navy commander to let her go ashore, but he ordered her to return that afternoon on a transport boat. Several days later, she was still on Okinawa, witnessing fighting, coming under attack and chronicling efforts of marine medical personnel at a field hospital. One night, she put down her camera to hold a flashlight for two hours over a wounded man while a doctor operated in the dark. On her last evening on Okinawa, a marine gave her a present, a .45-caliber bullet, just in case she was captured by the Japanese. Chapelle knew she had overstayed her orders, and when an MP finally caught up to her, she was placed under arrest and escorted off Okinawa. But she had gotten what she desired: to go as far forward as possible.

Maybe it started on Iwo Jima or perhaps on Okinawa, but Chapelle grew to love the marines, her compassion for them vividly illustrated in her photos and stories. And they loved her back.

"Marines were her favorite," said Jack Paxton, executive director of the Marine Corps Correspondents Association. "When somebody asked her, 'Why do you always go with the marines?' She said, 'That's where the action is.' She was just a favorite."

I interviewed Paxton in the fall of 2014 for a story in the *Milwaukee Journal Sentinel* when the Milwaukee Press Club inducted Chapelle into its hall of fame. It had been five decades since Paxton, then eighty-four, had spoken to Chapelle, but his memories remained fresh. Paxton met Chapelle in the mid-'50s, when she was covering an air show in Philadelphia hosted by the marines. Paxton hoped to escort Chapelle for the three-day event but was outranked by Johnny Carson's future sidekick, Ed McMahon.

"She had a great sense of humor. She didn't suffer fools very well. How she dealt with Ed McMahon, I'll never know," said Paxton, who spent twenty-two years in the U.S. Marines before retiring in 1969.

World War II was not the last time Chapelle put herself into harm's way, traveling to Algeria, Panama, Lebanon, Hungary, Cuba, the Dominican Republic and Vietnam on assignment for *National Geographic*, *Cosmopolitan*,

National Observer and other publications. After World War II, she and her husband went to Europe to photograph refugees for relief agencies, seeking to document the migration of people displaced by the war. Her camera and photos were confiscated by the Hungarian government in 1948, an event that probably deepened her hatred of Communism. She complained to the official who took her cameras, "Young man, you know I'm not a spy. But if you ever see me in Hungary again, you'd better shoot first. Because I will be."

She did return to Hungary; whether she was actually a spy is unknown, though biographer Roberta Ostroff thinks so. In her biography, *Fire in the Wind: The Life of Dickey Chapelle*, Ostroff wrote that the photographer was likely helping to smuggle penicillin to revolutionaries during the 1956 uprising while she was on assignment for *Life* magazine and working as a publicist for the International Rescue Committee. She was arrested and held for fifty-two days by the Russians, writing an article for *Reader's Digest* about spending Christmas in a Hungarian prison. She was found guilty in January 1957 of illegally crossing the border, instead of the more serious charge of espionage, and sentenced to time served.

Chapelle traveled to Vietnam several times in the early '60s, when American forces numbered only a few hundred advisers and only a handful of American journalists were there covering them. In 1962, she met a young AP reporter who would later win a Pulitzer Prize for his Vietnam coverage. Peter Arnett met her at the Caravelle Hotel in Saigon, a popular hangout for journalists, and recalled she was "petite and charming, not the brittle, aggressive personality I had envisaged from her legend." Though she was a couple decades older than many of the young journalists who would make names for themselves in Vietnam, she earned their respect through her competence, guts and professionalism.

As one of the first female journalists covering the Vietnam War, Chapelle coped with military leaders who tried to ban her from missions. One officer tried to stop her from covering a field operation by arguing that there were no toilets for women in the jungle.

"According to my AP colleague Fred Waters, Dickey, in her olive drab field gear, and her feet firmly planted on the ground, snarled at him, 'Listen soldier don't worry about me, and when I have to I can piss standing up straight just like you do!' Of course, Dickey went on patrol," Arnett recalled in an e-mail interview.

By the time she was in Vietnam, she was divorced from her husband and no longer using Speed Graphics, switching to lighter 35mm cameras. In the field, she carried two Leica cameras crossed on neck straps under each arm,

film canisters taped to the straps and three Leica lenses: 28, 35 and 90mm. Carrying a small pack filled with a change of fatigues and socks, soap and a towel, extra film and cans of military C rations, Chapelle was proud of the fact that she could live and work in the field for as many as three weeks. She learned to parachute from a plane and joined the military on dozens of jumps, proudly wearing on her Australian bush hat the paratrooper wings given to her by a commander. The photo she chose for the cover of her autobiography shows paratroopers leaping from a plane with a circle around one of the tiny forms: Chapelle. The American military advisers and South Vietnamese troops quickly understood she was a female correspondent who could keep up with them, who asked for no favors and who didn't want to be treated any differently than male journalists.

In her stories and lectures when she returned to the United States, often visiting Milwaukee, where she spoke to women's clubs and schools, Chapelle frequently talked about efforts to defeat Communism in Vietnam, a cause she supported. She was convinced that the South Vietnamese could defeat the Communist Viet Cong with the help of U.S. troops, and she tried to elicit support through her journalism and speeches.

In 1961, she joined two battalions of South Vietnamese paratroopers and two U.S. 101st Airborne Division military advisers on a mission near the Cambodian border for a story that appeared in the February 1962 edition of *Reader's Digest*. The unit was ambushed, and Chapelle was escorted into a village to photograph the corpse of one of the attackers, her escort explaining to her that as a child, he was forced to watch the murders of his parents by Communist troops in Hanoi.

She wrote about jumping half a dozen times with Vietnamese paratroopers and American advisers, walking more than two hundred miles in torrential rain and triple-digit heat and photographing the dead and wounded on both sides:

> *I did this out of a conviction that some American outside the military ought to know and report at firsthand what our allies against communism are doing, what they are able to do. What I saw convinces me that we can win in Asia if we will. With help, Vietnamese fighting men can be full allies of the West. They are intelligent, soldierly and better able to fight on their soil than our own troops. They have the will to win, but we must have the will to help them.*
>
> *If I have learned one lesson about warfare, it is that technical details are not the deciding factor in the battle, large or small. During my coverage*

of the front in Southeast Asia I saw again and again that rural Asians are capable of fighting for freedom as hard as ever it has been fought for anywhere including Lexington and Concord—or, for that matter, at Iwo Jima and in the streets of Budapest. This, I know, is what really matters.

This is the story I have been writing episode by episode, for 20 years; the story of men brave enough to risk their lives in the defense of freedom against tyranny. To me it has always been the most important story in the world.

Where, I wonder, will I next have the chance to go on observing it and telling of it?

She had more chances to observe and tell what was happening in Vietnam, visiting the country several more times. By October 1965, when Chapelle returned to write and report for the *National Observer* on a group of marine recruits she had followed through training, many journalists were in the country, drawn there to cover the large number of marine and army combat troops flooding into Vietnam. Unlike World War II and Korea, photographers and reporters had much easier access to the front thanks to helicopters.

"If you were accredited, and she was, if you heard there was a battle, all you had to do was hop aboard a chopper and off you went, you were in the middle of the battle," said Hal Buell, AP's former executive news photo editor who supervised the agency's photo operations during Vietnam. "She really took advantage of that and saw a lot of action."

When Chapelle returned to Vietnam in 1965, Paxton was there helping handle hundreds of war correspondents roaming the country. The military set up a media headquarters in a former French brothel in Danang, leasing rooms to the broadcast networks and wire agencies. When the Fourth Marine Division moved to Chu Lai, Paxton opened a small information bureau in a tent that could house up to ten reporters. In early November, Chapelle, forty-seven, was among nine journalists who flew in on helicopters to Chu Lai to cover the marines.

"I didn't know she was in the group until she got there and I'm checking off names. I said, 'My God, you're Dickey Chapelle.' I can't remember the retort, but it was funny," said Paxton, who told her they had met ten years earlier at the Philadelphia air show.

Paxton served with the Fifth Marine Division in Korea in 1951 and '52, when few journalists covered the war. He escorted author James Michener, who came to Korea for background on his novella *The Bridges at Toko-Ri*.

"In Korea we might see one correspondent or two our entire tour," said Paxton. "When Vietnam broke out in 1965, when the marines first got there, we had 550 reporters roaming all over the area. There was no control. They went wherever."

Paxton briefed Chapelle and the other journalists about Operation Black Ferret, an attempt to engage a large group of Viet Cong about twelve miles southeast of Chu Lai. The marines sent three units on the search and destroy mission, and Chapelle was assigned to one of the platoons. After the briefing, Paxton ate dinner with the journalists and chatted with Chapelle.

"She had seen more action than most of our marines had at that time. Stoic might be a good way to describe her mood. Anyone going into any action is scared. I'm sure she was nervous, but she didn't show it when we loaded them in the helicopters," recalled Paxton.

Paxton delivered the journalists to the flight line by 5:00 a.m., when they got in helicopters and flew off with the marines. Paxton would have joined Chapelle, but he had to stay behind in Chu Lai to meet CBS newsman Morley Safer, who was arriving a few hours later.

"The next thing I knew, I got a call from the regimental commander and found out she was killed," Paxton said.

A marine walking at the front of the platoon tripped a booby trap—fishing line connected to a hand grenade under a mortar round. The explosion blew him into the air, though he wasn't seriously injured. Walking right behind him was Chapelle, who was tossed about twenty feet. Shrapnel pierced her neck. Within minutes, she bled to death.

AP photographer Henri Huet, who would die in Vietnam a few years later, snapped a photo of a navy chaplain giving her last rites, kneeling beside her crumpled body, blood soaking through her fatigues. Within arm's reach was her Australian bush hat adorned with a sprig of pink flowers in the hatband and a U.S. Marine Corps pin. The pin had been given to her two months earlier by General Wallace M. Greene, the commandant of the Marine Corps, who took it off his uniform and presented it to Chapelle in his Washington, D.C. office when he heard she was going back to Vietnam to visit his troops.

Chapelle was the first American female correspondent killed in action and among the first American journalists to die in Vietnam.

Arnett, who gained fame during his coverage of the first Gulf War for CNN, said her dramatic death initially reinforced the official view that women had no place on the battlefield. General William Westmoreland, commander of U.S. military operations in Vietnam, attempted to ban female journalists.

"But Dickey's death, and Henri Huet's moving photo of its aftermath, also highlighted her own career achievements, helping to inspire a new generation of women to commit themselves to this dangerous branch of journalism," Arnett said. "By the end of the 1960s, female war reporters were no longer curiosities and had proved their competence as equals of males."

Her death was front-page news in her hometown newspapers; both the *Journal* and *Sentinel* printed photos of Dickey wearing her Australian bush hat. *The Milwaukee Journal* quoted an unnamed marine commander who said she never asked for any concessions because of her gender: "She'd spread her poncho in the mud like the rest of them and eat out of tin cans like she hated it, the way we do, not because it was something cute. In fatigues and helmet, you couldn't tell her from one of the troops, and she could keep up front with the best of them."

In the AP dispatch of her death, Huet said he helped her dig a foxhole on the evening they choppered in with the marines, despite her protests. They expected to be hit by mortars that night, but it was quiet. The next morning, Huet ate breakfast with Chapelle over a can of C rations. Then they split up to head out with different platoons. Huet was taking photos of a marine officer when he heard shouting and cries for a medical corpsman.

"I saw a group running about one hundred yards away. I ran with them and saw three or four bodies on the ground. One was facedown and soaked with blood. I couldn't tell who it was at first, but I looked more closely and suddenly realized it was Dickey," Huet said. "The corpsman checked her and told me nothing could be done for her in the field."

Her remains returned home to Milwaukee in a flag-draped coffin escorted by an honor guard of six marines, including one who had been tossed by the explosion that killed her—an unusual tribute for a civilian. After her funeral at the First Unitarian Church, she was buried at Forest Home Cemetery. Even though she was not a veteran or military member, she was given a marine funeral. Taps was played in her honor.

11

THE PROPHET AND THE WARRIOR

Years before Japanese military officers considered going to war with the United States, a Milwaukeean anticipated just such an attack. Not only did Billy Mitchell think Japan would one day attack the United States, but he also thought it would be an aerial bombardment on ships in an American harbor.

He was right, though off by a couple decades.

After visiting Japan while stationed with the army in the Philippines, Mitchell wrote in 1910, "That increasing friction between Japan and the U.S. will take place in the future there can be little doubt, and that this will lead to war sooner or later seems quite certain."

Mitchell is a tragic figure in American military history. He foresaw a need for a strong air force long before anyone else in the military, and to prove his point to skeptical commanders who thought the idea of planes sinking ships was absurd, Mitchell arranged a demonstration. It worked. He returned from World War I with a chest full of medals and a head full of ideas—ideas considered radical to a staid, rapidly downsizing military uninterested in preparing for future conflicts.

In speeches, books and magazine articles, Mitchell predicted that one day rockets would travel across continents and oceans and people would zip between New York and London in as few as six hours on fast commercial airliners. He foresaw air forces attacking targets with unmanned aerial vehicles—he didn't call them drones—and cruise missiles. He predicted that someday planes would be used for firefighting, evacuating the sick and

wounded, photographing terrain, crop dusting and spying on enemies, wrote Douglas Waller in his biography, *Question of Loyalty: Gen. Billy Mitchell and the Court-Martial That Gripped the Nation.*

"'A single explosion' well placed by aircraft in the heart of New York City, he once wrote, could wreck tall buildings, close the New York Stock Exchange, put communication and transportation systems 'completely out of order,' and paralyze briefly 'the financial center of the Western Hemisphere,'" wrote Waller.

Mitchell was not shy about his views. His desire to radically change the army and create a separate air force quickly spawned enemies in the government and military. Finally fed up with his insubordination, commanders demoted him and months later filed charges against him in a court-martial.

By the time Japanese torpedo bombers were dropping shells on the *Arizona*, *Vestal* and other ships in Pearl Harbor, Mitchell was dead. Within months of the Pearl Harbor attack, Doolittle's Raiders would make the first strike against the Japanese homeland in B-25 bombers named after Mitchell, the same plane that graces the entrance of Milwaukee's airport, also named after Mitchell. Jimmy Doolittle, the man leading the raid and flying the first B-25 off the deck of the aircraft carrier USS *Hornet*, had been a Mitchell aide.

Doolittle was awarded the Medal of Honor for the bombing raid of Japan. "He was ahead of his time," Doolittle said of Mitchell. But "the methods he used were so stringent that they destroyed him, and probably delayed the development of airpower for a period of time."

Decades before the attack on Pearl Harbor, Mitchell's father, Senator John Lendrum Mitchell, had bitterly denounced America's attempt to annex the Hawaiian Islands. While representing Wisconsin in the U.S. Senate, John Lendrum Mitchell grew disgusted by President William McKinley's policy of collecting land as war souvenirs, including Guantanamo Bay in Cuba, Puerto Rico and the Philippines. Hawaii, too, was coveted by business and military interests for its strategic location in the Pacific Ocean. To John Lendrum Mitchell, Hawaii was not America's to grab.

"Since the advent of the white man every leaf in the history of Hawaii is either red with blood or black with intrigue and jobbery," John Lendrum Mitchell said.

The joint congressional resolution annexing Hawaii passed on July 4, 1898. American military bases soon sprung up on Hawaii, and by 1906, the entire island of Oahu—which would become home to Pearl Harbor—was fortified by gun batteries.

The Prophet and the Warrior

John Lendrum Mitchell served as a first lieutenant in the Twenty-fourth Wisconsin Infantry Regiment during the Civil War along with Arthur MacArthur, participating in the Battles of Perryville, Murfreesboro and Chattanooga. Both men's sons would serve with great distinction, earn numerous medals, greatly affect the American military and end their careers under clouded circumstances. Billy Mitchell was court-martialed, and Douglas MacArthur was fired by the president.

The lives of Billy Mitchell and Douglas MacArthur were intertwined from childhood, when they were boyhood friends in Milwaukee. MacArthur was interested romantically in Mitchell's sister Ruth, professing his love in a poem to her, but she rebuffed him. Mitchell fought in the Philippines in 1898 in General Arthur MacArthur's division, and when Douglas MacArthur arrived in France in October 1917 as a major in the Forty-second Rainbow Division, Billy Mitchell was already in the country and welcomed him as commanding officer of the U.S. Air Service. Both belonged to the Alonzo Cudworth Jr. American Legion Post in Milwaukee. And in 1925, one of the jurors at Mitchell's court-martial was Douglas MacArthur.

Mitchell grew up in a wealthy Milwaukee family with strong political connections. His grandfather Alexander Mitchell emigrated from Scotland to Milwaukee and found work as a clerk with the new Marine Fire and Insurance Co., later founding what would become the Marine Bank and owning the largest railroad in the Midwest: the Milwaukee Road. Mitchell Street and Mitchell Park in Milwaukee are named after Alexander, whose son John Lendrum Mitchell became a politician after the Civil War. He served in the state senate and was president of the Milwaukee School Board before representing Wisconsin's Fourth District in the House of Representatives and then the U.S. Senate.

John Lendrum Mitchell and his wife were traveling in Nice, France, when their eldest child was born. Mitchell spent his first three years in France, and by the time his parents returned to Milwaukee, he spoke French better than English. When Mitchell turned eighteen, he enlisted in the army.

Mitchell joined the First Wisconsin Volunteer Infantry, considered one of the best state militias in the country with more than five thousand men divided into four regiments. His unit was sent to Camp Cuba Libre in Jacksonville, Florida, to train for fighting in Cuba in the Spanish-American War. But Mitchell was bitterly disappointed to miss out on the war—though he later served in occupation forces in Cuba—when he was commissioned an officer and posted to a signal corps unit in Washington, D.C.

The man who would eventually become known as the father of the U.S. Air Force became interested in aviation while stationed in Alaska. Bored

while snowed in and waiting for better weather to install telegraph wire for the army, Mitchell read articles on aircraft development. Fascinated by planes, he watched Orville Wright demonstrate the Wright Flyer in Virginia, took flying lessons and earned his pilot's license.

With so few pilots serving in the American military, Mitchell, almost by default, became an expert on aviation issues and was asked to help draft legislation to keep military aviation under the authority of the Army Signal Corps. Mitchell is credited with being the first American army officer to venture into the fighting trenches during World War I, where he saw the tactical folly of digging holes in the earth, which led to incredible losses of life and years-long stalemates. He quickly understood that planes could render trenches obsolete, so to gain the attention of policymakers in Washington, Mitchell persuaded the French premier to ask the U.S. War Department for 4,500 planes, five thousand pilots and fifty thousand mechanics to help the Allies gain air supremacy.

It was the start of America's air force.

He later wrote in his memoirs of the Great War that for armies to win, it was necessary to kill off opposing troops slowly, destroying a country's resources and people. Mitchell thought air power was the answer to the slaughter in the trenches:

> *Should a war take place on the ground between two industrial nations in the future, it can only end in absolute ruin, if the same methods that the ground armies have followed before should be resorted to. Fortunately, an entirely new element has come into being, that of air power. Air power can attack the vital centers of the opposing country directly, completely destroying and paralyzing them. Very little of a great nation's strength has to be expended in conducting air operations. A few men and comparatively few dollars can be used for bringing about the most terrific effect ever known against opposing vital centers.*

Mitchell served with Teddy Roosevelt's sons in France, and when Quentin Roosevelt, the former president's youngest son, was shot down and killed by German pilots in the skies over France in July 1918, Mitchell broke the terrible news to Roosevelt. Two months earlier, Mitchell had lost his only brother, John, in a plane crash in France.

Flying a French Spad two-seat observation plane and later an American-made Vought VE-7 fighter plane he adorned with his personal insignia—a silver eagle on a red field—painted on the fuselage, Mitchell repeatedly flew

Billy Mitchell stands next to his Vought VE-7 Bluebird plane in France during World War I. Mitchell's plane was adorned with his personal insignia—an eagle inside a maroon circle—which was later used in the design of the U.S. Air Force Combat Action Medal, created in 2007. *Courtesy of the U.S. Air Force.*

into enemy territory to see German lines and troop strength. He was not greatly skilled at combat but was a genius at air tactics. In September 1918, he organized an attack involving more than 1,400 planes flown by American, French, British and Italian pilots that knocked out German supply depots and aircraft hangars. He ordered fake hangars and fake planes built to fool German observation pilots into thinking the Allied air fleet was much larger, a tactic later used during World War II before the D-Day invasion.

Expecting war to continue into 1919, Mitchell devised an innovative plan to convert large, long-range aircraft into troop transports, each plane carrying ten to fifteen soldiers who could parachute behind enemy lines. The soldiers could assemble for action under cover of low-flying attack planes, Mitchell recommended, in a coordinated air and infantry assault. Resupplies of food and ammunition could be dropped by air. But the war ended in November 1918, and Mitchell soon was campaigning for a large expansion of military air power. He didn't think peace would last.

Mitchell ended his memoir of World War I, the only world war he would see, with an admonition. "I wondered how soon we should have to come

back to Europe in arms again—never, I hope. It is not our place unless we intend to take charge of the destinies of the world, which at this time seems a little premature," Mitchell wrote in 1928.

Mitchell was brash, bold and antagonistic. He was certain he was right, and anyone who disagreed became an opponent. He often was correct but needlessly made enemies of people who could have been valuable allies.

In April 1919, shortly after he was appointed chief of training and operations in the air service, he was invited by acting secretary of the navy Franklin Roosevelt to meet with navy commanders. Mitchell told the admirals that unless the navy developed an air force, its battleships were in danger of destruction from the air. He proposed building aircraft carriers and suggested arming planes with torpedoes, armor-piercing bombs and larger guns. In a *New York Herald* article in December 1919, Mitchell wrote, "Air power will prevail over the water in a very short space of time." A few months later, he used elaborate charts to illustrate to military commanders how, in his opinion, one thousand planes could be built for the same cost as one battleship.

Many of his words fell on deaf ears. He later learned his stream of memos became known in the War Department as "the flying trash pile."

By the early 1920s, Mitchell was growing more concerned about the military budget; he thought too much money was being spent on ships and not enough on planes. Convinced that aircraft were key to the military's future, Mitchell urged a demonstration of air power, pointing out that while an army fights on land and a navy fights on water, an air force could do battle over both. But secretary of the navy Josephus Daniels was having none of it. So convinced of the navy's superiority over planes, he warned Mitchell that if he tried to drop bombs on ships, Mitchell's planes would be shot down long before they could get close. Daniels upped the ante by saying he would stand on the deck of any ship Mitchell tried to attack from a plane.

In testimony before a congressional committee, Mitchell vividly described what would happen from direct hits on ships as bombs falling from the sky pierced decks and superstructures: blasts would create fires, killing everyone on the upper decks, breaking lights and throwing the ship into complete darkness below deck, disrupting all communication systems, filling rooms with poisonous fumes, causing shell shock to most on board, disrupting ammunition delivery systems and exploding antiaircraft shells stored in ammunition compartments. His description eerily described the grisly scene on board the USS *Arizona* on December 7, 1941.

Mitchell persisted in his attempts to demonstrate air superiority, and in 1921, he organized six U.S. Air Service squadrons in the sinking of a former

The Prophet and the Warrior

German World War I battleship, the *Ostfriesland*, repeating the exercise with other obsolete ships. The demonstrations antagonized navy officials.

Three years later, while honeymooning with his second wife, Mitchell toured Hawaii and Asia to inspect America's military assets. The couple spent a month and a half in Hawaii, where Mitchell surveyed airfields, talked to mechanics, watched pilots demonstrate their flying capabilities and checked training schedules. After touring China, Korea, Japan, Siam, Singapore, Burma, Java, the Philippines and India, Mitchell wrote a 340-page report warning that the Asia-Pacific Rim could soon rival Europe in military might, and America's security depended on its foothold in the region. To Mitchell, however, Japan was the country that posed the greatest threat because of its growing military strength and its quest for external sources of oil and iron for Japanese industries.

In his 1925 book, *Winged Defense*, Mitchell detailed how Japan might attack Hawaii—starting at 7:30 a.m. with sixty Japanese pursuit planes destroying hangars and planes on the ground at Schofield Barracks, followed by one hundred bombers striking Pearl Harbor's naval base and the city of Honolulu.

Though Mitchell correctly predicted the Japanese attack on Pearl Harbor, he did get some things wrong. He thought the Japanese would attack using land-based airpower with submarines transporting airplanes in crates for assembly at an airfield on the northern Hawaiian island of Niihau and bombers flown from Midway Island. He undervalued aircraft carriers, contending that the large ships could not operate efficiently nor launch a sufficient number of aircraft for a concentrated operation. Also, Mitchell didn't need a crystal ball to predict a Japanese offensive at 7:30 a.m. since military commanders often favor morning attacks.

Mitchell's career effectively came to an end—though it could be said it was a long time coming—with the fatal crash of the navy dirigible *Shenandoah* in September 1925 and the unnecessary loss of three navy seaplanes traveling to Hawaii. Because the navy had scheduled a packed itinerary for the *Shenandoah* to visit twenty-seven cities between New Jersey and Iowa, the dirigible's commander was under pressure to arrive on time at each city. Admirals did not want to disappoint local politicians. Over Ohio, the *Shenandoah* flew into a storm, and though it could have steered clear, the dirigible would have missed local fair appearances, and the captain continued into the squall. It crashed, killing fourteen crewmen, including the captain.

Mitchell was apoplectic. In a nine-page, single-spaced statement he issued to the press, he wrote, "These incidents are the direct result of the incompetency, criminal negligence and almost treasonable administration

of the national defense by the Navy and War Departments." One month later, he was court-martialed. At his seven-week trial in November and December 1925, the youngest of the dozen jurors deciding Mitchell's fate was MacArthur, who later called his task "one of the most distasteful orders I ever received."

Hap Arnold, the future leader of the U.S. Air Force, and World War I flying ace Eddie Rickenbacker were among those testifying for Mitchell. Defense counsel argued that Mitchell should not have been punished for speaking out against the crash of the *Shenandoah*, claiming it was a First Amendment issue. But ultimately, the jury convicted Mitchell of conduct that discredited the military. He was suspended from duty for five years without pay. Within two months of the verdict, Mitchell resigned. He spent the next decade writing articles and talking to anyone who would listen about the need for a strong air force. He died in 1936 of influenza and, following his funeral at Milwaukee's St. Paul's Episcopal Church, was buried at Forest Home Cemetery in Milwaukee next to his father and grandfather.

The personal insignia he ordered painted on his World War I plane was incorporated into the U.S. Air Force Combat Action Badge, first awarded in 2007 to air force members who come under enemy fire. The medal features a crimson- and gold-striped ribbon and a medal of an eagle clutching arrows surrounding by a laurel wreath.

Like Mitchell, MacArthur's grandfather was a Scottish immigrant who settled in Milwaukee and quickly made a name for himself. Even though Arthur MacArthur Sr. left Glasgow at the age of seven, his speech never lost the Scottish burr. He was a lawyer and judge who was elected city attorney just two years after arriving in Milwaukee. In the strangest gubernatorial election in Wisconsin history, Arthur MacArthur Sr. served as governor for four days. Running for lieutenant governor in 1855 with fellow Democrat and running mate William A. Barstow, the election was marred by rigged votes from fictitious precincts and a 157-vote winning margin for Barstow—which soon blew up when his campaign opponent threatened violence backed by an ad hoc militia that descended on the Capitol in Madison. Unfazed, Barstow and Arthur MacArthur Sr. were sworn in, but eventually Barstow resigned within a few months, on March 21, 1856, leaving MacArthur as governor. Four days later, the state Supreme Court ruled in favor of Republican Coles Bashford. Arthur MacArthur Sr. was bumped back down to lieutenant governor and served out his term.

His son Arthur MacArthur Jr. was living in Milwaukee when the Civil War began and wanted to immediately enlist, but instead his father wrote

to Abraham Lincoln requesting an appointment to West Point. Arthur MacArthur Jr. visited Lincoln in the White House, where the president told him there were no openings at the military academy. So at the young age of seventeen, with the help of political pull from his father, he was commissioned a first lieutenant and appointed adjutant of Wisconsin's Twenty-fourth Volunteer Infantry Regiment. He fought in numerous battles, including Chickamauga, Stones River, Franklin and the campaign for Atlanta. Arthur MacArthur Jr. earned the Medal of Honor for his actions at the Battle of Missionary Ridge in Tennessee, when the first soldier carrying the Twenty-fourth Regiment's flag was bayoneted and an exploding shell decapitated the second. MacArthur picked up the flag that had been carried by the regiment since it left Milwaukee, ran at full speed to the crest of the ridge despite getting hit twice by bullets and planted it in the ground while shouting, "On Wisconsin!" Officers were rarely awarded the Medal of Honor for bravery in combat during the Civil War; instead, they were rewarded with promotions. But regulations were later changed, and in 1890, he received the Medal of Honor.

When his son was awarded the Medal of Honor for his leadership during World War II, the MacArthurs became the first father and son to earn the prestigious medal. The only other pair to earn the Medal of Honor is Teddy Roosevelt, posthumously awarded the medal in 2001 for his actions on San Juan Hill in Cuba during the Spanish-American War, and his son Theodore Roosevelt Jr., who fought in both world wars.

After leading the Twenty-fourth Regiment in a parade through downtown Milwaukee when the unit returned home from the Civil War, Arthur MacArthur Jr. made a career in the military. He moved from base to base—his son Douglas was born in army barracks in Little Rock, Arkansas—took part in the campaign against Geronimo, met Buffalo Bill Cody and Wild Bill Hickok and commanded a brigade in the Philippines during the Spanish-American War. He was briefly military governor of the Philippines after the war, sent to Manchuria as an observer during the Russo-Japanese War and served as military attaché at the U.S. embassy in Tokyo. Arthur MacArthur Jr. butted heads with William Howard Taft when the future president was appointed civilian governor general of the Philippines in 1900, which MacArthur saw as an affront to his military leadership of the country. Perhaps Arthur MacArthur Jr. thought he was tangling with a relatively unknown politician from Ohio, but Taft happened to be a close friend of Teddy Roosevelt, who appointed Taft secretary of war in 1904. When Taft was elected president in 1908, Arthur MacArthur Jr. saw the writing on the wall.

He retired as a three-star general at the age of sixty-four and remained active in his Grand Army of the Republic unit of Civil War veterans in Milwaukee. Perhaps fittingly for a man who devoted most of his life to the army, he died surrounded by his men. Though ill, he accepted a request by his veterans to speak at their meeting on September 5, 1912, in Milwaukee on the fiftieth anniversary of the unit's creation. Shortly into his speech, he collapsed and died of a heart attack on the stage. His men took down a flag hanging on a wall and tenderly wrapped his body in it. It was the flag he had carried to the top of Missionary Ridge.

By the time his father died, Douglas MacArthur was also making a career in the army. After attending the West Texas Military Academy, MacArthur set his sights on West Point. But despite efforts by his grandfather and father to secure an appointment, he failed to get in. Then he flunked a physical exam because of curvature of the spine. His mother moved herself and her son to Milwaukee in 1897 to establish residency in Congressman Theobald Otjen's district and to get her son's spine corrected with the help of a Milwaukee specialist. Otjen had run unsuccessfully to replace John Lendrum Mitchell after Billy Mitchell's father resigned from the House of Representatives to become a senator. Otjen was eventually elected to serve six terms in the House.

MacArthur and his mother lived in the Plankinton House hotel at what are now Wisconsin and Plankinton Avenues while he worked with the specialist to correct his back and studied with a tutor at West Division High School for the exam given to the thirteen young men vying for Otjen's sole West Point nomination. Not only did MacArthur pass the test, but he also merited a brief story in the June 7, 1898 edition of *The Milwaukee Journal*, which said, "Young MacArthur is a remarkably bright, clever and determined boy."

After graduating at the top of his class in 1903—earning the highest grades since Robert E. Lee was a West Point cadet—MacArthur was assigned to the Army Corps of Engineers and, following engineering school, was sent to Milwaukee to handle river and harbor duties. He lived with his parents in a three-story mansion. It would be the last time MacArthur lived in the city, though he took pride in his membership of the Cudworth American Legion Post in Milwaukee until his death in 1964.

Like Mitchell, MacArthur was a polarizing figure. As his biographer William Manchester wrote in *American Caesar*, "He appeared to need enemies the way other men need friends, and his conduct assured [*sic*] that he would always have plenty of them."

It's not a stretch to say that no American military commander has been more controversial than MacArthur. Egotistical. Ambitious. Brave. Brilliant.

He was eccentric and paranoid, vain and imperious. He was charming, flamboyant, smart, noble and inspiring. He was a complex genius who flouted authority.

At the end of World War II, he was appointed to oversee the rebuilding of Japan and is credited with instituting reforms that helped the country ultimately become a world power—installing a democratically elected government; encouraging land reform and the rise in trade unions; and drafting a new constitution that stripped the emperor of military authority, guaranteed fundamental human rights and outlawed racial discrimination. When North Korea invaded South Korea in 1950, President Harry Truman picked MacArthur to lead the fight. MacArthur ordered the successful amphibious landing at Inchon, but when China sent hundreds of thousands of troops to aid North Korea, American- and United Nations–backed troops were forced to retreat. MacArthur publicly disagreed with Truman's suggestion to offer a negotiated peace, and the president quickly sacked him.

Like his friend Mitchell, MacArthur's stellar military career ended in disgrace.

Early in his career, he used his father's powerful connections but also made a name for himself with his hard work and intellect. MacArthur commanded the Forty-second Rainbow Division in France before world wars required numbers. He was appointed commandant of West Point right after World War I, bringing his old friend Mitchell to speak to the cadets about aviation in the skies over France and Germany. Sitting in the West Point audience that day in 1920 listening to Mitchell's one-and-a-half-hour speech of air battles were future commanders of the next world war. Among them was Maxwell Taylor, who would become the first Allied commander to land in France on D-Day and later be appointed chairman of the Joint Chiefs of Staff, and Milwaukee native Hoyt Vandenberg, who held a number of critical positions in the U.S. Army Air Corps, including commanding general of the Ninth Air Force in Europe. The namesake of Vandenberg Air Force Base, he led what later became known as the Central Intelligence Agency.

MacArthur was promoted to major general in 1925, becoming the youngest to hold that rank at the age of forty-three. He led the U.S. Olympic Committee in the 1928 Amsterdam Olympics and was named army chief of staff in 1930.

Five years later, he was appointed military advisor to the Philippines, a country he had visited often when his father was stationed there. Accompanied by aides that included Dwight Eisenhower, MacArthur faced a big challenge in building a Filipino military, basically starting from scratch—from constructing airfields and organizing a general staff to recruiting and training soldiers.

General Douglas MacArthur in Manila, Philippines, August 1945. *Courtesy of the Library of Congress.*

Creating a viable military force in the Philippines was not simply an exercise but a necessary endeavor to act as a counterweight to Japanese aggression in the region. Relations between America and Japan had spiraled downward since the invasion of Manchuria in 1931 and worsened when Japan marched into central China in 1937.

MacArthur had visited Japan for the first time in 1904 with his father and been impressed. Now more than three decades later, he continued to marvel at the country's strong, disciplined military.

"Cooped up within the narrow land mass of their four main islands, the Japanese were barely able to feed their burgeoning population. Equipped with a splendid labor force, they lacked the raw materials necessary for increased productivity," MacArthur said. "They lacked sugar, so they took Formosa. They lacked iron, so they took Manchuria. They lacked hard coal and timber, so they invaded China. They lacked security, so they took Korea. It was easy to see that they intended, by force of arms if necessary, to establish an economic sphere completely under their control."

When the Japanese attacked Pearl Harbor, MacArthur was awakened in Manila by a phone call. He considered sending reconnaissance planes to determine whether Japanese aircraft were headed toward the Philippines but initially decided against it—which turned out to be a disastrous decision. When the order finally came a few hours later for a mission, the B-17 bombers and fighters were being fueled and loaded with bombs, parked wingtip to wingtip, as Japanese squadrons swooped down on American airfields. Within a short time, MacArthur's Far Eastern Air Force was decimated—18 of 35 B-17s lost, 53 of 107 P-40s and 3 P-35s gone, along with 25 other aircraft, hangars, barracks, supplies and refueling trucks.

It was a portent of things to come for American forces in the Philippines.

American military commanders developing plans for a possible Japanese invasion of the Philippines knew Japan could not be prevented

The Prophet and the Warrior

from landing on the important island of Luzon. The plan was for American soldiers in MacArthur's garrison to retreat to the Bataan peninsula and wait for rescue by the Pacific Fleet. But military planners didn't consider that those ships would end up at the bottom of Pearl Harbor. The Philippines were doomed. No help would arrive.

MacArthur moved his headquarters onto the island of Corregidor while American and Filipino forces fell back to Bataan. In February 1942, as Japanese forces closed in, President Roosevelt ordered MacArthur to evacuate to Australia with his wife and son and a handful of senior staff to take command of Pacific forces. After a two-day PT boat ride and a flight on a B-17, MacArthur landed in Australia and vowed to return to the Philippines. He left behind thousands of American troops under Major General Jonathan Wainwright, who held out for a few months before they were captured and forced to walk to prisoner-of-war camps in what became known as the Bataan Death March.

MacArthur made good on his promise, splashing ashore two and a half years later, after directing Allied forces throughout the Pacific, as a photographer snapped an iconic photo of the general wading through knee-deep water. When the Japanese finally capitulated following the atomic bomb attacks on Hiroshima and Nagasaki, it was MacArthur who accepted the surrender on behalf of the Allies in a twenty-three-minute ceremony on the deck of the USS *Missouri*. Standing behind MacArthur as he sat at a table to sign his name, using five different Parker pens manufactured in Janesville, Wisconsin, was Wainwright, gaunt and gray after three years of captivity. Wainwright would later say of MacArthur, "I'd follow that man anywhere blind folded."

After surrender documents were signed, MacArthur stepped to a microphone and spoke to people listening by radio around the world. He said, "It is my earnest hope, and indeed the hope of all mankind, that from this solemn occasion a better world shall emerge out of the blood and carnage of the past—a world dedicated to the dignity of man and the fulfillment of his most cherished wish for freedom, tolerance and justice."

BIBLIOGRAPHY

Bloch, Robert. *Once Around the Bloch: An Unauthorized Autobiography*. New York: Tor Books, 1993.

Breaking News: How the Associated Press Has Covered War, Peace and Everything Else. Princeton, NJ: Princeton Architectural Press, 2007.

Brysac, Shareen Blair. *Resisting Hitler, Mildred Harnack and the Red Orchestra: The Life and Death of an American Woman in Germany*. New York: Oxford University Press, 2000.

Bunker, John. *Heroes in Dungarees: The Story of the American Merchant Marine in World War II*. Annapolis, MD: Naval Institute Press, 1995.

Chapelle, Dickey. *What's a Woman Doing Here? A Reporter's Report on Herself*. New York: William Morrow and Company, 1962.

Elwood-Akers, Virginia. *Women War Correspondents in the Vietnam War, 1961–1975*. Metuchen, NJ: Scarecrow Press, 1988.

Frank, Richard B. *MacArthur: A Biography*. New York: St. Martin's Griffin, 2009.

Gurda, John. *Cream City Chronicles: Stories of Milwaukee's Past*. Madison: Wisconsin Historical Society Press, 2006.

Bibliography

———. *The Making of Milwaukee.* Milwaukee, WI: Milwaukee County Historical Society Press, 1999.

Hatfield, Jerry. *Inside Harley-Davidson: An Engineering History of the Motor Company from F-Heads to Knuckleheads, 1903–1945.* Osceola, WI: Motorbooks International, 1990.

Holmstrom, Darwin, ed. *The Harley-Davidson Century.* Osceola, WI: Motorbooks International, 2004.

Jasper, Joy Waldron, James P. Delgado and Jim Adams. *The USS Arizona: The Ship, the Men, the Pearl Harbor Attack and the Symbol that Aroused America.* New York: St. Martin's Paperbacks, 2003.

Jeffers, H. Paul. *Billy Mitchell: The Life, Times and Battles of America's Prophet of Air Power.* St. Paul, MN: Zenith Press, 2004.

Kaltenborn, H.V. *Europe Now: A First-Hand Report.* New York: Didier, 1945.

———. *Fifty Fabulous Years, 1900–1950: A Personal Review.* New York: G.P. Putnam and Sons, 1950.

———. *It Seems Like Yesterday.* New York: G.P. Putnam and Sons, 1956.

Larson, Erik. *In the Garden of Beasts: Love, Terror and an American Family in Hitler's Berlin.* New York: Crown, 2012.

Lochner, Louis P. *Always the Unexpected: A Book of Reminiscences.* New York: MacMillan Co., 1956.

———. *What About Germany?* New York: Dodd, Mead & Co., 1942.

———, ed., trans., with an introduction. *The Goebbels Diaries, 1942–1943.* New York: Doubleday, 1948.

Manchester, William. *American Caesar: Douglas MacArthur, 1880–1964.* Boston: Little, Brown & Co., 1978.

Mitchell, William. *Memoirs of World War I.* New York: Random House, 1960.

Bibliography

Nagorski, Andrew. *Hitlerland: American Eyewitnesses to the Nazi Rise to Power.* New York: Simon & Schuster, 2013.

Nelson, Anne. *Red Orchestra: The Story of the Berlin Underground and Circle of Friends Who Resisted Hitler.* New York: Random House, 2009.

Ostroff, Roberta. *Fire in the Wind: The Life of Dickey Chapelle.* New York: Ballantine Books, 2001.

Perry, Mark. *The Most Dangerous Man in America: The Making of Douglas MacArthur.* New York: Basic Books, 2014.

Pifer, Richard L. *A City at War: Milwaukee Labor During World War II.* Madison: Wisconsin Historical Society Press, 2003.

Prange, Gordon W. *At Dawn We Slept: The Untold Story of Pearl Harbor.* New York: McGraw-Hill, 1981.

Raymer, Commander Edward C. *Descent into Darkness, Pearl Harbor, 1941: A Navy Diver's Memoir.* Novato, CA: Presidio Press, 1996.

Shirer, William L. *Berlin Diary: The Journal of a Foreign Correspondent, 1934–1941.* Boston: Little, Brown & Co., 1941.

Waller, Douglas. *A Question of Loyalty: Gen. Billy Mitchell and the Court-Martial that Gripped the Nation.* New York: HarperCollins, 2004.

Wright, David K. *The Harley-Davidson Motor Company: An Official Eighty-Year History.* Osceola, WI: Motorbooks International, 1987.

Yates, Brock. *Outlaw Machine: Harley-Davidson and the Search for the American Soul.* Boston: Little, Brown & Co., 1999.

INDEX

A

adjustable resistor 68
aircraft carriers 14, 68, 130, 134, 135
Air Force Combat Action Badge 133, 136
Alaska 131
Algeria 123
Allen-Bradley 68
Allentown 66
Allis-Chalmers 61, 64, 65, 68–70
Alonzo Cudworth Jr. American Legion Post 131, 138
American Peace Society 98
American Women's Club 86, 88
Anderson, Marian 87
A.O. Smith 61–62, 65, 70–72
Army-Navy "E" Awards 55
Army Signal Corps 132
Arnett, Peter 124, 127–128
Arnold, General Henry H. "Hap" 136
Associated Press (AP) 14, 82, 95–96, 98, 103–104, 108
Astor Hotel 67
Astor, John Jacob 109
Astor, Vincent 109
Australia 49, 125, 141

B

Balboa 44
Barstow, William A. 136
Bascom Hall 84
Bashford, Coles 136
Bataan Death March 141
Bataan peninsula 141
Battleship Row 13, 20
Bazelon, Emily 93
Belvin, Jesse 35
Berchtesgaden 112
Berlin 79, 80, 84–93, 95–96, 98–106, 107–108, 115, 116
Berliner Tageblatt 88
Blatz beer 29
Bloch, Robert 15, 38–41
Bohn, John L. 46
Bolshevik revolution 109
Bonaparte, Napoleon 97
Bradley, Lynde 68
Bridges at Toko-Ri, The 126
Briggs and Stratton 63
Brooklyn Daily Eagle 109–110
Brown, Edwin H. 69–70
Browne, Jack 28–29, 32–35
Brussels 90–91

INDEX

Brysac, Shareen Blair 81, 85, 87–88, 90
B-17 Flying Fortress 61, 70–72, 140–141
B-25 Mitchell 130
B-24 Liberator 52, 61, 70–71
B-29 Superfortress 56, 61, 70–71
Buell, Hal 126
Burma 135
Byrd, Admiral Richard "Dickey" 118

C

Cagney, Jimmy 18
Camp Carl Schurz 76
Camp Hindenburg 15, 73, 75–76
Cape Esperance, Battle of 23
Cape Town 44, 45
Carlson, Marion 82
Carson, Johnny 123
Cass Elementary School 19
Castro, Fidel 35
Central Intelligence Agency 139
C-47 70–71
Chamberlain, Neville 100
Chapelle, Dickey 117–128
Chapelle, Tony 119–120
Charlottenberg Prison 92
Chattanooga, Battle of 131
Chicago Bears 21
Chicago Cardinals 21
Chicago Tribune 86
Chicago World's Fair, 1893 97
Chickamauga, Battle of 137
China 49, 120, 135, 139–140
Chu Lai 126–127
Citron, William M. 76
Civil War 16, 19, 63, 131, 136–138
Clinton, President Bill 35
CNN 127
Cochran, Dan 109
Cody, Buffalo Bill 137
Cold War 67, 81
Colliers 109
Columbia Broadcasting System 110
Communism 86, 124, 125

Compiegne, 1940 surrender 102
Constitution Hall 87
Cooke, Sam 35
Corregidor 141
Cosmopolitan 123
Craig, John D. 28
Cuba 35, 44, 67, 123, 130, 131, 137
Curtiss-Wright Field 118
Cutler-Hammer 63
Czechoslovakia 100, 114–115

D

Danang 126
Daniels, Josephus 134
Daughters of the American Revolution 87
D-Day 61, 121, 133, 139
decompression sickness 28
DESCO Corp. 26, 29, 30–34
destroyers 19, 24, 68
Detroit 63, 74
Dewey, Thomas 77
Diem, Carl 87
Dodd, Martha 86–88, 90
Doddridge 67
Dodd, William E. 86, 88
Dominican Republic 123
Doolittle, Jimmy 130
Doolittle's Raiders 130
Dos Passos, John 88

E

East Side High School 19
Edmonds, Walter D.
 Drums Along the Mohawk 87
Eisenhower, Dwight 139
electromagnetic process 69
Emerson, Ralph Waldo 84
End, Edgar 28
Enthusiast 51, 53

F

Falk Corp. 61, 67
Faulkner, William 88

Index

Federation of German-American Societies of Wisconsin 43
Ferdinand, Archduke Franz 109
Fifth Marine Division 126
First Aero Squadron 53
first Gulf War 127
First Unitarian Church 128
Ford, Henry 98
Forest Home Cemetery 46, 128, 136
Fort Knox 70
Forty-second Rainbow Division 131, 139
Foster, Jim 21–22
Fourth Marine Division 126
Fourth Wisconsin Volunteer Infantry 108
Fox Point, Wisconsin 28, 35
France 49, 53, 89, 102, 109, 131–132, 139
Franklin, Battle of 137
Free Society of Teutonia 73
French Spad airplane 132
Freud, Sigmund 109
Friends of New Germany 74
frigates 66, 67
Froboese, George 74–78
Froemming, Ben 66, 67
Froemming Brothers Shipyard 65, 67
Froemming, Herbert 66
Froemming, Walter 66

G

gaseous diffusion 69–70
Gauer, Harold 38, 41
Gein, Ed 38
German Mine Worker's Federation 99
German Social Democratic Party 99
German U-boats 15, 44
Geronimo 137
Gestapo 15, 81, 86, 91, 99, 103, 115
Glacier Girl 72
Globe-Union 63
Goebbels, Joseph 88, 95–96, 99
Goering, Hermann 80
Goethe, Johann 84, 90
Gooding, Cuba, Jr. 35
Gorki, Maxim 98

Grafton, Wisconsin 15, 73
Graham, Donald 21
Grand Army of the Republic 138
Green Bay Packers 21
Greenland 72
Groves, General Leslie 69
Guadalcanal, Battle of 14, 23, 115
Guam 67, 120, 121, 123
Guantanamo Bay 44, 130
guillotine 16, 79, 92–93
Gurda, John 68

H

Haiti 45
Hanfstaengl, Ernst "Putzi" 110–111
Hanoi 125
Harley-Davidson 49–56, 58–59
Harley, William S. 54
Harnack, Arvid 15, 79, 84–85, 86–87, 93
Harnack, Mildred 15–16, 79–93, 97
Harvard University 109, 110
Hatsutaka, Japanese minelayer 58–59
Havana 35, 118–119
Hawaii 14, 19, 21, 58, 115, 120, 130, 135
Heath, Donald 87
Heath, Donald, Jr. 87
heavy cruisers 68
Hemingway, Ernest 88
Hickok, Wild Bill 137
Hindenburg, dirigible 98
Hinrichs, Hans 97
Hiroshima 24, 67, 141
Hitchcock, Alfred 15, 38
Hitler, Adolf 15–16, 77, 79–82, 84–86, 93, 95, 98–100, 102–105, 107, 110, 112, 113, 114, 115
Hoan, Daniel 38–41
Hoover, President Herbert 105
Hope, Arkansas 35
Hoyer, Emmy 97
Huet, Henri 127–128
Hungary 123–124
Husemann, Fritz 99

Index

I

Inchon 139
India 135
Indonesia 66
Ireland 28
Iron Curtain 81
Iwo Jima 24, 117, 120–123, 126

J

Janesville, Wisconsin 141
Janz, Bill 34
Japan 14, 27, 67, 68, 98, 129–130, 135, 139–141
Java 135
Johnson, President Lyndon 105

K

Kaltenborn, H.V. 14, 89, 97, 107–115
Kaltenborn, Rolf 108
kamikaze attack 24
Karachi, Pakistan 44–45
KC-135 Stratotanker 65
Kennan, George 103
Kennedy, President John F. 105–106
KGB 87
Kidd, Rear Admiral Isaac C. 19–23
Kinnickinnic River 66
Knox, Frank 21
Koellner, Ric 32
Korea 126–127, 135, 139–140
Kristallnacht 100
Kuckhoff, Adam 84, 90–91
Kuckhoff, Greta. *See* Lorke, Greta
Kuehn, Norman 28
Kunze, Gerhard Wilhelm 74, 77

L

Ladish Co. 61
La Follette, Fighting Bob 46
La Follette, Robert, Jr. 46–47
Lake Mendota 84
Lake Michigan 28, 34, 57–58, 63, 66
Larson, Erik 86, 107

La Salle, steamship 43–45
Latta, Frank 49, 56, 58–59
Latta, Mike 58–59
Lebanon 123
Lee, General Robert E. 138
Leica 124–125
Lend-Lease Act 14, 49
Leningrad 102
Lenin, Vladimir 110
Lincoln County Anzeiger 108
Lincoln High School 38
Lincoln, President Abraham 79, 92, 137
Little Rock, Arkansas 35, 137
Lochner, Friedrich 97
Lochner, Louis 14, 82, 95–105, 108, 110–112
Lochner, Robert 105–106
London 114–115, 129
London, Jack 88
Lorke, Greta 84–85, 88, 90–91
LST 61, 68
Luftwaffe 61, 80, 86, 90
Lusitania 28
Luzon 141

M

MacArthur, Arthur, Jr. 136–137
MacArthur, Arthur, Sr. 131, 136
MacArthur, General Douglas 16, 131, 136, 138–141
Madison Square Garden 77
Madison, Wisconsin 82, 84, 90, 92, 103, 136
Manchester, William 138
Manchuria 137, 140
Manhattan Project 68–70
Manila 140
Manitowoc Shipbuilding Co. 56–57
Marine Bank 131
Marine Fire and Insurance Co. 131
Mark V dive helmet 25–27, 29–30, 32–33, 35
Marquette University 28, 41
Marston mats 65

Index

Marxism 74, 85
McCarthyism 47
McCarthy, Senator Joseph 15, 46–47
McKenzie, Bernice 33–34
McKinley, President William 130
McMahon, Ed 123
Medal of Honor 14, 16, 21, 23–24, 130, 137
Mehring, Walter 88
Mein Kampf 84, 98, 114
Men of Honor 35
Merchant Marine 15, 23, 42–44
Merrill Advocate 108
Merrill, Wisconsin 108–109
Messersmith, George 89, 107–108
Michener, James 126
Milcor Steel Co. 61, 65
Milwaukee Auditorium 15, 74–75, 104
Milwaukee Free Press 97
Milwaukee Germania 97
Milwaukee Journal Sentinel 123
Milwaukee Journal, The 38, 43, 65, 69, 70, 74–76, 82, 100, 108, 123, 128, 138
Milwaukee Press Club 104, 123
Milwaukee Public Library 41
Milwaukee River 73, 82
Milwaukee Road 131
Milwaukee Sentinel 34, 43, 76, 78
Minneapolis 19
Missionary Ridge, Battle of 137, 138
Mississippi River 63
Mitchell International Airport 65
Mitchell, John Lendrum 130, 131, 138
Mitchell Park 131
Mitchell, Ruth 131
Mitchell Street 131
Mitchell, William "Billy" 14, 21, 129–139
Moeller, Karl 75–76
Moscow 77, 87, 109
Murfreesboro, Battle of 131
Mussolini, Benito 99, 113

N

Nagasaki 24, 67, 141
National Geographic 123
National Observer 124, 126
Navy Cross 21
navy salvage divers 23, 26, 29–33
Nazi Party 87–88, 105
New Guinea 66
New York Navy Yard 19
New York Stock Exchange 130
Nieman Fellowships 109
Nimitz, Admiral Chester W. 23
1938 Munich pact 100
1936 Berlin Olympics 88, 105
1932 Los Angeles Olympics 87
1928 Amsterdam Olympics 139
Ninth Air Force 139
N.L. Kuehn Rubber Co. 28
Nohl, Mary 35
Nohl, Max Gene 28, 35
Nordberg Engineering Co. 77
Nuremberg Trials 104

O

Oak Ridge, Tennessee 70
Okinawa 24, 123
Omaha Beach 61
101st Airborne 125
126th Air Refueling Squadron 65
126th Observation Squadron 65
"On Wisconsin!" 137
Operation Black Ferret 127
Ostfriesland 135
Ostroff, Roberta 124
Otjen, Theobald 138

P

Panama 120, 123
Panama Canal Zone 15, 44, 57
Parker pens 16, 141
Paxton, Jack 123, 126–127
Pearl Harbor 13–15, 19–20, 22–23, 25, 27, 29, 32, 37, 41, 46, 53,

Index

65–66, 78, 95, 102–104, 115, 120, 130, 135, 140–141
Perryville, Battle of 131
Persia 87
P-51 Mustang 61
P-40 Warhawk 140
P-47 Thunderbolt 72
Philippines 16, 66, 129–131, 135, 137, 139–141
Pifer, Richard L. 63, 65
Plötzensee Prison 79, 92
plutonium 69
Poland 76–77, 87, 90, 95, 102, 114
Prins Willem V shipwreck 35
Prinz-Albrecht-Strasse 91
Prussia 91, 97, 108
Psycho film and book 15, 38
P-38 Lightning 72
P-35 140
Puelicher, Albert S. 43
Puerto Rico 130
Pulitzer Prize 95, 100, 124

R

Raymer, Edward C. 25–27
Reader's Digest 124–125
Red Cross 82
Red Orchestra (Rote Kapelle) 15, 79–82, 84, 90, 93, 99
Reed, John 109
Reichstag 85
Revolutionary War 19, 87
Rickenbacker, Eddie 136
Riverside High School 19, 66
Rockefeller scholar 84
Roosevelt Dam 18
Roosevelt, President Franklin 14, 18, 77, 88, 134, 141
Roosevelt, President Teddy 132, 137
Roosevelt, Quentin 132
Russia 32, 49, 77, 109
Russo-Japanese War 137

S

Safer, Morley 127
Saigon 105, 124
Saipan 121
Sandburg, Carl 86
Sandusky 66
Santayana, George 87
Sarajevo 109
Schofield Barracks 135
Schulze-Boysen, Harro 90–93
Schulze-Boysen, Libertas 91–93
Scripps-Howard newspaper chain 120
scuba 25, 35
Seabees 61, 68
Shakespeare, William 84
Shenandoah, navy dirigible 135–136
Shorewood High School 118
Siam 135
Sinclair, Upton 88
Singapore 19, 59, 135
Solomon Islands 23, 115
Soviet Union 15, 49, 67, 77, 79, 85, 89–90
Spanish-American War 108, 131, 137
Spanish Civil War 110
Speed Graphic camera 122
Springfield, Illinois 96
Stalingrad 80
Stalin, Joseph 79, 89
Star Trek 15
Stead, William T. 98
Sterling Hall 84
Stieve, Hermann 93
Stone, Irving
 Lust for Life 87
Stones River, Battle of 137
storm troopers 77, 107
Sudetenland 100, 114
Sullivan brothers 24

T

Taft, President William Howard 137
Tarzan 28
Taylor, Maxwell 139

Index

Tesla, Nikola 65
Timmerman Airport 118
Titanic 98, 109
Tokyo 137
Treaty of Schönbrunn 97
Truman, President Harry S 139
tugboats 66
Twenty-fourth Wisconsin Infantry Regiment 131

U

U-159, German submarine 44–45
University of Berlin 85, 93
University of Wisconsin 15, 82, 84, 90, 92, 97–98
uranium 69
U.S. Air Service 131, 134
U.S. embassy 96, 105, 137
U.S. Naval Academy 13, 17, 19–20
U.S. Naval Reserve 41
U.S. Olympic Committee 139
USS *Arizona* 13, 17–24, 25–27, 115, 130, 134
 band 21, 23
USS *Atlanta* 24
USS *Cassin Young* 24
USS *Eldorado* 121
USS *Hawkbill* 58–59
USS *Hornet* 130
USS *Juneau* 24
USS *Lagarto* 49, 56, 58–59
USS *Missouri* 16, 141
USS *Nevada* 20
USS *Oklahoma* 20
USS *Samaritan* 117, 121
USS *San Francisco* 23–24
USS *Van Valkenburgh* 24
USS *Vestal* 13, 20–24
U.S. Treasury 70, 89
Utah Beach 61

V

Vandenberg Air Force Base 139
Vandenberg, Hoyt 139
Van Gogh, Vincent 87
Van Valkenburgh, Franklin 13–14, 16, 17–24, 26
Viet Cong 125, 127
Vietnam 52, 123–127
Vietnam War 65, 124
Villa, Pancho 53
Voice of America 67, 105
Volksbund (the Bund) 15, 38, 73–74, 76–77, 89
von Haugwitz, Count Christian 97
von Kaltenborn-Stachau, Baron Rudolph 108
von Stauffenberg, Claus 81
von Wiegand, Karl 110–111

W

Wainwright, Major General Jonathan 141
Waldinger, Joel 93
Waller, Douglas 130
Wallerstein, Ruth 82
War of 1812 19
Washington, D.C. 20, 45, 47, 89, 127, 131
Washington, President George 19, 74, 77
Waters, Fred 124
Wauwatosa, Wisconsin 82
Weissmuller, Johnny 28
Weller, Oree Cunningham 17
Wells, Daniel, Jr. 19
West Division High School 41, 82, 97, 138
Westmoreland, General William 127
West Point Military Academy 16, 137–139
West Texas Military Academy 138
Whitman, Walt 79, 84, 92
Wilder, Thornton 86, 88
Wilson, Jackie 35
Wilson, President Woodrow 18
Wisconsin Club 67
Wisconsin Conservatory of Music 97, 102

Index

Wisconsin Federation of German-American Societies 76
Wisconsin Industrial Commission 54
Wisconsin Literary Magazine 84
Wisconsin Magazine of History 68, 112
Wisconsin Maritime Museum 59
Wisconsin National Guard 43, 65
Wisconsin State Journal 84
Witte, Captain Helmut 44–45
Wolfe, Thomas 88
Woman's Day 120
World War I 18, 26, 53, 65, 77, 85, 96, 98, 102, 105, 109–111, 120, 129, 132–133, 135–136, 139
Wright Flyer 132
Wright, Orville 132

Y

Young, Cassin "Ted" 13–14, 16, 20–24

Z

Zeidler, Anita 41, 43–44, 46
Zeidler, Carl 15, 37–47, 76, 82
Zeidler, Clara 37
Zeidler, Frank 41, 45–46
Zeidler, Mike 37

ABOUT THE AUTHOR

Meg Jones has been a journalist for more than half her life, working for small daily newspapers in Wisconsin, as well as *USA Today*, where she wrote short blurbs for eight states every day on the "Across the States" page, which was enjoyable for a time but she doesn't miss that type of writing. For the last two decades, Meg has been a reporter for the *Milwaukee Journal Sentinel*, covering a wide variety of news, including many stories about military and veterans' issues. She was part of a *Milwaukee Journal Sentinel* team that was a Pulitzer Prize finalist for explanatory reporting. She earned a bachelor's degree in journalism and history from the University of Wisconsin–Madison, where she rowed on the crew team, wrote for the *Daily Cardinal* and *Badger Herald* and played drums in the UW marching band, which did not give her much free time to goof off. Meg was born in Rhinelander, Wisconsin, which officially makes her a Hodag. She owns a Cheesehead hat. With the publication of this book, she can finally call herself an author.

Courtesy of the Milwaukee Journal Sentinel.

Visit us at
www.historypress.net

This title is also available as an e-book